PAGAN, GODDESS, MOTHER

Edited by Nané Jordan & Chandra Alexandre

T0287724

DEMETER

Pagan, Goddess, Mother

Edited by Nané Jordan and Chandra Alexandre.

Demeter Press
2546 10th Line
Bradford, Ontario
Canada, L3Z 3L3
Tel: 289-383-0134
Email: info@demeterpress.org
Website: www.demeterpress.org

Demeter Press logo based on the sculpture "Demeter" by Maria-Luise Bodirsky www.keramik-atelier.bodirsky.de

Printed and Bound in Canada

Cover artwork: *Mary,* Acrylic on Canvas, Asia Morgenthaler
Cover layout and typesetting: Michelle Pirovich

Library and Archives Canada Cataloguing in Publication
Title: Pagan, goddess, mother / edited by Nané Jordan and Chandra Alexandre.
Names: Jordan, Nané, editor. | Alexandre, Chandra, editor.
Description: Includes bibliographical references.
Identifiers: Canadiana 20200376233 | ISBN 9781772582642 (softcover)
Subjects: LCSH: Motherhood. | LCSH: Mothers—Religious life. | LCSH: Paganism. | LCSH: Goddess religion.
Classification: LCC HQ759.P34 2021 | DDC 306.874/308829994—dc23

For our children now and yet to come.
With love,
Nané

To my mom and daughter.
Prema,
Chandra

Acknowledgments

Nané: Writing a book is surely an act of birthing and mothering; it is a calling to bring new word worlds into life through our labours while acknowledging both the challenges and joys of raising the sweet child before us. I, thus, want to acknowledge and thank Dr. Sarah Whedon, who first approached me with the idea for this book, inviting me to coedit this anthology with her. I was to take a secondary role in its birthing, as Sarah began the editorial process with the authors. Sarah's academic background and spiritual pathway is in Pagan studies, and my own are in women's spirituality and Goddess studies. We began complex conversations via email on the topic of forwarding the experiences of mothers in these connected yet diverse spiritual communities, which are often marginalized or little understood outside of their own lived terrains. When Sarah needed to step back from coediting the anthology, I was left with a book partway through and with her original vision. I was able to step into to the challenge of raising our child-book with the support of my new coeditor, Dr. Chandra Alexandre and continue on with this heartfelt work, feeling the blessings of forwarding the many mother voices in this text.

I want to thank Chandra for her input and support. I also very much thank all our authors for their amazing, insightful, and moving writing about this important topic and for their patience with us as editors. My gratitude continues with thanks to my husband and daughters, the loves of my life, who are ever supportive of my creative writing life, typing away as I do on this cosmic sewing machine.

Chandra: I've felt blessed to have been part of this anthology under Nané's leadership and Sarah's vision. It's been a hard and joyful experience, as is much to what we give birth in this world. My appreciation to those who stepped up to write and create with us and to those upon whose shoulders we stand is great. In service to the larger birthing of a healed and whole world, I offer my appreciation to my own family for

their support as I make my contributions. Thank you to the readers too, now, for taking in these many and varied gifts. May your own journeys be fulfilled within Her embrace.

Nané and Chandra: Our combined thanks and gratitude especially go out to Dr. Andrea O'Reilly and Demeter Press for gracefully moving through this project with us and, as always, for holding much needed publication space for vital mother voices in feminist scholarship.

And to you, Mother Goddesses everywhere, in gratitude for and with your creative presences—at times both nurturing and fierce in your directions—we give thanks for all experiences of love and support in our efforts, birthing us along the way.

Contents

Introduction

Nané Jordan and Chandra Alexandre

I am the Mother of all things and my love is
poured out upon the earth...
I who am the beauty of the green earth and the white moon
among the stars and the mysteries of the waters,
I call upon your soul to arise and come unto me.
For I am the soul of nature that gives life to the universe.
From Me all things proceed and unto Me they must return.
Let My worship be in the heart that rejoices, for behold,
all acts of love and pleasure are My rituals.

(From *Traditional Charge of the Goddess* by Doreen Valiente,
adapted by Starhawk)

This book gathers creative voices, stories, and scholarship from the forefront of Pagan and Goddess-centred homes—where Goddesses, divine Mothers, female embodiment, and generative life cycles are honoured as sacred. Pagan and Goddess spirituality are distinct yet overlapping traditions, lived through diverse communities in North America and beyond. Those who inhabit these spaces have much to say about deity as mother and about human mothers in relationship to deity. This anthology puts Pagan and Goddess mothering into focus by highlighting the philosophies and experiences of mothers in these movements and spiritual traditions. By doing so, we hope to generate new ways of imagining and enacting motherhood.

Questions informing this collection are as follows. How do mothers in contemporary Pagan and Goddess movements negotiate their mothering roles and identities? How does devotion towards Mother Goddesses empower and/or affect the lived experiences of mothers and feminist practices of mothering? As editors, we wondered how Pagan-

and Goddess-centred mothers engage in, and are affected by, their particular spiritual leadership through practices of ceremony, ritual, magic, priestessing, as well as through living connections with nature, the more-than-human world, the Earth as Mother, and our own bodies. We were curious to know how Pagan- and Goddess-centred mothers interface with dominant religions, the public sphere, social institutions for children, community leadership, and social justice movements. We were curious especially because Pagan and Goddess spirituality are not mainstream religions, nor are they accepted as such. Adherents often co-create new pathways, subcultures, or countercultures in life and spirit. Practitioners may or may not belong to particular communities or faith-based groups and may even practice traditional religions alongside their Pagan and Goddess spirituality.

For many, the term "spirituality" rather than "religion" best describes Pagan and Goddess philosophies and ways of life. Spirituality may be equated with the search for meaning in life; it is related to sensing the more-than-material world of the sacred, numinous, or divine—feeling interconnections within the web of life, and all that is. Spirituality often describes subtle human experiences that are immanent (from within) and/or transcendent (from outside) of the self. Spiritual experiences often have transformative, healing, or uplifting qualities. For some practitioners, Pagan and Goddess spirituality are understood as growing from the roots of ancient religions or as reclaimed from pre-Christian spiritual worldviews. Pagan- and Goddess-loving individuals may be hidden in their communities and face misunderstanding from mainstream religion and society. Conversely, others live openly and identify with particular pathways, groups, or circles, gathering in designated places of worship to practice their spiritual expression.

What especially intrigued us, as editors, is the knowledge gained from our own experiences, struggles, and insights with Goddess spirituality. In this, our practices and experiences of mothering have been uniquely affected by living spiritual paths that value women, the sacred female and feminine, daily embodied life, and mothers themselves as divine and part of the sacred cycle of life. We particularly live our mother-centred spirituality as women seeking to engage in nonpatriarchal spiritual practices and leadership. We see this form of spiritual feminist leadership reflected in this volume—through stories of those who support and uplift women as mothers in their communities and through

the voices of mothers who strive to live in balance with male partners and/or the men in their lives. Many Pagan- and Goddess- identified mothers and mother-centred people find their spiritual pathways to be life-enhancing alternatives to patriarchal, male-centred religions. In particular, Goddess spirituality, as a women- and female-empowering movement, has grown out of social gender justice and feminist movements in North America and beyond (e.g. Hwang et al., Robbins Dexter and Noble; Sjoo and Mor, Spretnak).

Some common principles to both Pagan and Goddess spirituality are a love of nature and the Earth as sacred; knowing the Earth as our Mother; a respect for the elements and the more-than-human worlds of trees, plants, earth, water, and animal life; belief in the importance of the unseen realms; valuing embodied life and our bodies as sacred in female and all gendered forms; honouring the seasons and the cosmic turning of the wheel of the year; and appreciating the depth of interconnections between birth, life, and death. Through the authors represented herein, this anthology examines the pleasures, struggles, and challenges of living Pagan- and Goddess-centred truths as mothers raising children towards postpatriarchal, Earth-based, and love-centred lives, which recognize the pain of suffering alongside the importance of healing, compassion, and the pursuit of an interconnected, joyful life. Such mothers are striving to unleash their own and their children's fullest potential from worldviews that honour the female/feminine and mothers as divine and sacred to all life. Engaged in and uplifting Pagan- and Goddess-centred spirituality, this anthology reveals the tensions and insights of these communities, philosophies, and practices for empowering and healing the lives of mothers as well as the next generation.

Pagan, Goddess, Mother: The Matrilineage of the Editors

We wish to acknowledge this anthology as born from the inspiration of Dr. Sarah Whedon. Sarah is a faculty member of Cherry Hill Seminary, a specialized seminary for advanced degrees in Pagan studies and ministry. Sarah teaches women's and religious studies in the Boston area; she is also a doula working in the birth justice movement and was managing editor of the online magazine *Pagan Families*. The current editors, Nané Jordan and Chandra Alexandre, are alumnae of graduate

degree programs in women's spirituality in the San Francisco Bay Area—a vital locale for Goddess-centred spiritual practice, scholarship, and activism. Sarah is Pagan-identified, while Nané and Chandra are practitioners and scholars of women's spirituality, of Goddess and mother-centred devotions, although we differ in our expressions of such.

Originally from New York, Chandra is a Tantric Bhairavi (female initiator), social justice advocate, and mother, who has served as a spiritual leader for over 20 years in the San Francisco Bay Area through SHARANYA, which is a federally recognized Goddess temple that Chandra founded in 1998 after receiving direction from her teacher in India to "Go spread Mother worship!"

Nané is an artist-scholar, a community worker, and a mother of two young adult daughters. Nané has been active in the midwifery and mother-centred birth movement in Canada for over thirty year as an advocate, a practitioner, and a researcher. She develops holistic birth-based philosophy and writing, with particular focus on mothers' birth stories and the gifting morphology of the placenta through the mother-baby dyad (*Placenta Wit*). She is currently a social worker in an urban Indigenous community, engaged in family support and healing. Over her lifetime, Nané has been immersed in, and contributes to, feminist arts and scholarship on women's spirituality, Goddess studies, and eco-feminist, Mother Earth–based wisdom.

We share these backgrounds to introduce the diverse pathways of the authors in this volume. Though such diversity, we do not propose singular definitions for each of the contested and complex terms of "Pagan" and "Goddess." Rather, we offer guidelines to uphold multiple expressions of each, emerging as these do from alternative, life-honouring streams of living spirituality.

As editors, we locate ourselves as mothers in the third wave of matricentric feminism (O'Reilly, *Matricentric*)—a "mother-centred model of feminism" (3) that extends and transforms practices of mothering beyond limiting and oppressive conditions of patriarchal motherhood. Through matricentric feminism, mothering can be understood as socially and historically constructed (4). Mothering is approached as a life practice with personal and social agency rather than being a naturalized, oppressive, or unquestioned identity. Feminist motherhood scholar Fiona Green describes how matricentric feminist

mothering challenges the institution and ideology of motherhood to become a site of empowered social practice for mothers, in which "feminist mothers make space in their mothering in which they actively engage in alternate practices of raising children" (89). Pagan and Goddess mothers, with their alternate spiritual pathways being interconnected with feminist philosophies, are forging new grounds in this regard. Religion and spirituality deeply impact subjective understandings and worldviews as well as lived experiences of the body, family, and community, and the values with which mothers raise their children. We, thus, note ourselves as matricentric feminist mother-scholars, who are devoted to our family lives as equally as to our spiritual and working lives. We seek empowerment, self-actualization, social justice, and change. We strive for intricate corelations among the spiritual, scholarly, community, leadership, healing, and mothering aspects of the various spaces we inhabit.

Pagan and Goddess: Unruly Terms

Pagan and Goddess spiritual movements and practices are multifaceted and diverse—it is not our intention to define and debate these various theologies, thealogies, philosophies, and traditions. Rather, this anthology adds to the literature of these fields from mother- and family-centred perspectives, offering insight to the study of women and others as mothers in religion and spirituality. We have chosen to capitalize the terms "Pagan" and "Goddess" to keep these two terms in view throughout our introduction. But this need not be so—anthology authors may or may not capitalize these terms in the chapters that follow. The mother-authors of this anthology are each unique in their voices and visions, reflecting how Pagan and Goddess pathways allow for differing expressions and multiple contexts.

Throughout Western, European-based history, the terms "Pagan" and "Goddess" were deemed derogatory titles. The term "Pagan" was historically used in a negative sense to define and denigrate non-Christians as being heathens or irreligious (Ball 423). This was especially so as Christianity came to dominate all forms of faith and spirituality in the European historical context and extended into European histories of global colonization. In its contemporary, Western-based spiritual use, the term "Pagan" has been reclaimed to honour the beliefs and practices

of pre-Christians, of sacred Indigenous and ancestral spiritual traditions, and regarding contemporary polytheistic (multiple divinities), Earth-based, and pantheistic or panentheistic (divinity as pervading nature and the cosmos) views. In this, nature, all life forms, and the land itself, including elements of water, fire, earth, and air, are regarded as sacred, alive, and full of spirit, with the human body being equally sacred. From the term Pagan comes the "neo-Pagan" movement, which references the modern revival of Pagan beliefs, deities, festivals, and celebrations (Adler). From its Latin root, Pagan means a "country dweller," as in peoples who lived closely with the Earth and the cycles of nature. As defined in this volume by Pagan theologian Christine Hoff Kraemer, Western spiritual movements in contemporary Pagansim include "Wicca, Druidry, Heathenry, and various reconstructionist Polytheisms" (this volume). Further terms for Pagan spirituality include "the Craft" or the "Old Religion," which refer to the aforementioned pre-Christian religious identification and involve valuing women's wisdom and female spiritual power.

Another unruly term related to Pagan and Goddess spirituality is the infamous "witch." As noted by women's history scholar Max Dashu, "Modern Western culture is saturated with demonized concepts of the witch, while lacking knowledge about authentic cultural practices of its own past" (59). Dashu points to lineages of the term "witch" across proto Indo-European languages as related to words for "wise woman," "wisdom," and "seer, prophet, or sage" (60). The witch as an archetypal female figure—with her European history of vilification through the mass persecution of women in the historical "Burning Times" (Reid), turned modern, magical icon of North Amer-ican movie and TV fame (e.g., *Harry Potter* and *Maleficent*)—is a powerful, galvanizing term. Some Pagan and Goddess practitioners have reclaimed the word "witch" to identify themselves. For witches, this statement reclaims and empowers women's social status, self-authorization, and bodied, sexual life-giving capacities beyond patriarchal control. Contemporary witches identify across Pagan and Goddess spiritual pathways—seeking to break through historical and contemporary misogyny and to offer liberation through a spiritual revival of female/feminine power and magic for modern life. The practice of magic is active in many traditions as a tool for nature-, self-, community-, and spirit-based connections, with potential for trans-formation, healing, and inner growth through rituals and celebrations.

Paganism writ-large encompasses many peace-loving ways of life. Most Pagan communities value individual autonomy and self-actualization. Some operate under a hierarchical order with progressive levels of leadership, whereas others engage community consensus. Furthermore, some Pagans chose to practice alone. Deities worshipped or honoured in Paganism come from wide-ranging sources—including ancient Greek, Egyptian, British, Irish, African, East Asian, and Middle Eastern traditions—and may reflect male, female, or gender fluid forms. Some Pagans honour sacred wisdoms, such as the Tarot or Kabbala, whereas others access pantheons and deities from folklore and myth in an extensive array that can be both personal and varied (Adler).

Traversing this spiritual terrain, "Goddess" is an equally contested term. Being an "other" to male-centred divinity, this word claims the power of female/feminine divinity in singular and multiple forms. Whereas some people may speak of and honour "the Goddess" as a singular Supreme Being, others worship Goddesses from many cultures and/or in many forms. Feminist theologian Mary Daly pointed out over forty years ago in, *Beyond God the Father,* that patriarchal religions revering a male-only, father God tend to legitimize hierarchical, power-over, and oppressive relations in daily social life that place male above female and father over mother. Countering these patriarchal symbolic, physical, and psychological effects, Goddess spirituality in its contemporary North American feminist revival seeks to empower and validate women's lives, bodies, and spiritual experiences (Christ). Goddess as a spiritual "She," thus reflects, through varied female and feminine forms, the experiences of women's lives through a diversity of expressions and traditions.

Reclaiming Goddess(es) in singular and multiple forms has been a central practice of the women's spirituality movement in North America. Women's spirituality as a social movement is conjunct with feminist politics. Although it includes secular concerns for women's rights and critiques of patriarchy towards women's empowerment, women's spirituality goes further to reimagine religion, culture, society, personhood, and community from spiritualized, postpatriarchal views (Spretnak). Women's, feminist, and Goddess spirituality struggled to give birth to and liberate the very notion of Goddess. Through such spiritual, cultural, political, and bodied liberations—often anathema to the views and practices of organized religion—visions and practices of female-centred

spirituality have emerged through contemporary practices. These traditions are forwarded and embodied by American women's spirituality leaders, such as Elinor Gadon, Luisah Teish, Zsuzsanna Budapest, Vicki Noble, and Judy Grahn. As editors, we note these particular names, as we studied with these feminist foremothers in the San Francisco Bay Area. We also acknowledge the many women and others who further lead and co-create together through vital, emergent pathways.

Contemporary practitioners of Goddess spirituality may practice solo or be part of larger organized communities. Such organizations include the emergence of registered Goddess Temples, such the Glastonbury Goddess Temple in England, which celebrates the local Goddesses of Avalon and the British Isles (Jones), or Chandra's own Devi Mandir (Goddess Temple), SHARANYA, in the San Francisco Bay Area. SHARANYA engages Divine Mother Goddess worship in a lineage tradition from India, offering a sanctuary to many.

Goddess practitioners may act as priestess-leaders in their communities; they hold women's circles in person and online and create leadership pathways and communities dedicated to personal and planetary transformation in service to such values as compassion, social justice, self-care, and truth. This includes the priestess work of author Molly Remer in this volume, who tends the Creative Spirit Circle of Brigid's Grove. Such practitioners may work in tune with the seasons and the bodied cycles of women's lives. They gather people to celebrate and ritualize menstruation, pregnancy, birth, mothering (of children or projects), menopause, and the passage to Crone in becoming elders, creating reflective spaces for women to share life stories and ideas.

Celebrating the creative forces of female bodies and mothering itself through Goddess spirituality is felt to support women's lifecycles as interconnected to the vitality of relationships, work, creative projects, and activism. Experientially, the Goddess and divine feminine is not merely an external object of worship, but it lies within—alive in the body itself as sacred. This is not meant to essentialize femaleness but to liberate bodied oppression, and to become more rooted in one's body and life, with the power to self-authorize needs, yearnings, and choices. American dance educator Vajra Ma notes that although feminism has developed "crucial cognitive understandings to dismantle patriarchal concepts," women "still need to cultivate full embodiment at the subtle, neural level ... to restore their wombs and subtle bodies ... the next wave

of feminism must take women fully into the body" (233). Women living from their "wild feminine" (Kent) through Goddess spirituality reclaim creative potentials of their womb sources and resources from previously unexplored or even traumatized bodied lives due to patriarchal social conditioning, restrictions, and harm. Additionally, a postpatriarchal religion or spiritual pathway that validates and holds space for Mother Goddesses alongside the lived experiences of mothers provides vital supportive qualities to mothers' challenging lives, as noted by authors in this anthology.

Many Goddess practitioners' identify with pre- or postpatriarchal matriarchal, matrifocal (mother-centred) societies. Contemporary research on mother-centred societies, past and present, contributes to emergent understandings of matriarchal worldviews as systems that sustained human life for a millennia before the current patriarchal, two-thousand-year cycle of human societies, which have become increasingly destructive for life on Mother Earth (e.g., Gimbutus and Goettner-Abendroth). Drawing from this root of matriarchal scholarship, revering the female form as a Goddess, a Divine Mother, or female creator, is understood to predate the worship of a male-centred, father God (Baring and Cashford; Eisler; Stone). Female-bodied forms were the central subjects of prehistoric and Neolithic artwork, highlighting the sacred capacity to give birth and nurture life in balance with a sustaining male/masculine gender. Ancient cultures drew synchronic, symbolic relationships between the generative maternal body and gifting cycles of Earthly life in the bounty of the land. Archeological evidence has unearthed the dwellings and rites of early European peoples, who appeared to have lived in interrelationship with natural forces and cycles of life, with plants and animals of the Earth as Mother (Gimbutus; van der Meer). Despite modern society's disconnection from and plundering of Mother Earth, human beings continue to depend on Her for life and thriving. Goddess- and Divine Mother-loving spirituality honours Mother Earth as gifting us life, beauty, and sustenance in the plants, trees, animals, resources, and elements with which we are deeply interrelated.

Speaking to the term "Goddess," American Pagan and priestess-witch Starhawk noted over thirty years ago that "Whenever we feel the slightly fearful, slightly embarrassed sensation that words like *Goddess* produce, we can be sure we are on the track of a deep change in the structure as well as the content of our thinking" (4). Yet such deep

change takes time. It may be that younger generations are freer to claim "Goddesses" without censure as compared to their feminist foremothers. The potential of Goddess spirituality for women as mothers is to obtain superseding or shared rights and rites (political, spiritual, cultural, and embodied) with their male and fatherly counterparts. However, in North America and worldwide, women continue to face the lived realities of patriarchal cultures and systems, along with political and economic structures of oppression that dominate their lives. Even the living Goddess traditions of India struggle with the place of women and mothers in a patriarchal, caste-based society, as noted by author Kusumita Mukherjee Debnath in this volume. Regarding the South Asian context, authors contend that one can be a Goddess worshipper by day, yet still abuse women by night (Hiltebeitel and Erndl).

Yet a vision of contemporary Goddess spirituality is that Mother Goddesses draw from and legitimize female-centred and maternal embodied social powers, with diverse expressions of the feminine being possible beyond gendered norms. The term "Goddess" can be a potent common ground for multiple pathways and experiences for women as mothers and men as nurturers as well as for transgender people and nonbinary or gender-fluid folks. All are sacred expressions of the human life force and source. Goddess may be a noun for some and a verb for others. As noted by Mago Goddess scholar Helen Hye-Sook Hwang, "S/he" is the Great Goddess and Primordial Mother (5). Goddess is the Creatrix, the First Mother, a supreme progenitor—*MAAAAA!* Goddess is a way of life and knowing, a way of being that honours and upholds, rather than oppresses or demotes, feminine and female forms of being human. The Goddess we know and love is inclusive and vast—birthing, beholding, and nurturing the sacredness of all.

Following Pagan, Goddess, Mother Threads

As editors, we see obvious interconnections between Pagan and Goddess traditions for empowering practices of actual mothers and mothering. Yet this is the first anthology we know of to explore this field from the perspective of mothers and matricentric (mother-centred) feminism. This gap of knowledge may be explained by the ongoing lack of focus on mothers and mothering as subjects of academic study and inquiry, despite humans being born from mothers.

As noted by motherhood studies leader and scholar Andrea O'Reilly,

the study of motherhood and mothering remains peripheral to academic feminism ("Matricentric" 19). In pursuing matricentric feminism, O'Reilly notes that "Motherhood is the unfinished business of feminism" (14). Intriguingly, we note that "spirituality" and "Goddess" also remain sidelined topics in academia (Jordan, *Inspiriting*), as little material is found in any coursework or research across North American universities, despite our knowledge of the many vital scholarly and practice-based contacts and communities in these fields. Thus, to amalgamate Pagan and Goddess spirituality with matricentric feminism brings new perspectives forwards from both fields, with much material remaining to be uncovered. O'Reilly notes that one of the governing principles of matricentric feminism is that it "commits to social change and social justice, and regards mothering as a socially engaged enterprise and site of power, wherein mothers can and do create social change through childrearing and activism" ("Matricentric" 18)

For us, Goddess is the penultimate extension, expansion, and worldview of matricentric feminism. Through a spiritualized matricentric worldview, Goddess as deity, symbol, energy, form, culture, creative power, and practice feeds our daily lives as mothers, and nourishes our lives as people who engage in the gifting work of social change. We know the value of the motherwork we do, and the maternal gifts we give (Vaughan). We cocreate with and expect the support of others in raising our children. We equally value our self-actualization as spirited human beings. Thus, mothering is an ongoing weaving of many threads for thriving of self and other as in the philosophical value of "eudaimonia," which refers to human flourishing and the blessedness of a life well lived.

As editors, we value how the mother-scholar authors in this anthology pursue what O'Reilly terms "the matrifocal narrative." In such narratives, mothers play "a role of cultural and social significance in which motherhood is thematically elaborated and valued, and is structurally central to the plot" (*Matricentric*, 5-6). To begin exploring Pagan and Goddess spirituality through the lens of matricentric feminism, *Pagan, Goddess, Mother* is divided into three sections, with a total of thirteen chapters, including essays and poems. We mention the number thirteen, as we can only think that Goddess is giving us a wink—thirteen being, in the esoteric literature, the perfect coven (gathering circle) of witches. The number thirteen was also made famously unlucky in Western culture. Yet for Pagans and Goddess lovers, the number thirteen is well known as the original lunar calendar. This

denotes the yearly cycle of thirteen moons for tracking human time on Earth. Furthermore, the phases of thirteen moons are interconnected with the timing of the life-giving female menstrual cycle, where body and cosmos are united as sacred cycles of life.

The first section, "Priestess, Witch, Artist, Midwife: Mother Stories," opens the anthology. We delve into mothers' narratives from the forefronts of home-, self-, and life-making as Pagan- and Goddess-loving mothers. In "Mamapriestess," Molly Remer explores the intricate interconnections among her birthing, mothering, and Goddess spirituality priestessing in her working-from-home life. Remer is the home-based priestess of Brigid's Grove, through which she leads and teaches Goddess-centred women's spirituality programs, circles, and rituals. Her story deeply expresses how Goddess as Mother affirms her worth and value in her own maternal role. Remer shares and reflects upon her study of contemporary American priestesses who are, like herself, in the "immersive stage of life as a mother."

Sarah Rosehill, in "Finding my Footing as a Witch and a Mother," shares the intensity of birthing and becoming a mother to her daughter, alongside insights into her spiritual life as a witch, through the path of Anamanta, which "invites us to open to the world around us—the earth, the wind, the lake, the stars." Rosehill's experiences of early mothering are deeply informed by her Pagan pathway, where she finds solace and joy in surrendering to the demanding new rhythms of her mothering life. Mothering is coenriched by her spiritual life, revealing the deeper meanings of each.

In "Remothering and the Goddess," Asia Morgenthaler reveals her interconnected journeys of becoming a mother and an artist as well as the enrichment of her life pathway through her relationship to the Goddess. As Morgenthaler emerges as an artist, she finds Goddess images pour through her, creatively healing childhood and family wounds. Morgenthaler artfully reclaims her once strained relationship to the figure of the Virgin Mary through Goddess-led meanings and symbolism and the power of painting "her sacred face." Her artwork from her series "Mary" graces this anthology cover.

In her poem, "Minks," Elizabeth Cunningham tells a mother-daughter story of remembering across the generations. In this, a wise daughter, wearing an old mink coat from her grandma, prays to heal the family's past transgressions.

The chapter written by Welsh midwife and professor, Alys Einion, is

titled, "'Call Unto Thy Soul': A Reflexive Autoethnography of a Pagan, Priestess, Goddess-Worshipper, and Mother." Einion explores interlinking threads of her varied life roles, including her early-life dedication to the Goddess, her experiences as a lesbian woman and mother, and her service to women's birthing powers as a midwife. Einion's experiential and embodied dedication to her Goddess and birth-work pathways creatively reveals "the ecstasy of that femaleness, of the sheer power of what some call our physicality, but which cannot be separated from the divine. We are Goddess."

The next book section, "Scholarship from Pagan Goddess Motherlines," centres on three authors who provide thought-provoking propositions in developing mother-centred Pagan- and Goddess-based analyses, theologies, and philosophies. This section opens with Pagan theologian Christine Hoff Kraemer's chapter, "Pagan Mothering, Body Sovereignty, and Consent Culture." Kraemer, a mother and Pagan, describes the powerful paradox in Pagan communities of seeking one's tribe while yearning for personal autonomy. She uses this lens to discuss the ethics of touch. Kraemer explores this from a Pagan view to provide a guide for consent culture in the context of mothering children, with strides towards building a more empathetic community.

Next is Kusumita Mukherjee Debnath's chapter, "I Do Not Want to Be a Goddess." Muhkerjee Debnath explores the conditions she faces in her Hindu homeland of India through the constructed trapping of women in stories and dictates of Goddesses Lakshmi and Alakshmi. Revealed through Hindu scripture and myth, Muhkerjee Debnath speaks to this cultural and religious landscape and what it means in her own life to feel the challenges of these juxtaposed Goddesses. These leave her in a quandary of expected duties to family and beliefs that restrict women in a world of men. She speaks to the inequities this entails, in which women in their sanctioned roles of wife and mother must support the household, whereas their personal aspirations and intelligences are eschewed. Muhkerjee Debnath ends on a hopeful note through her decision to emancipate herself from these Goddesses through a reinterpretation of how she has been taught to know them.

In the next chapter, "The Path of the Cold Hearth-Stone: Reflections on Sex, Saturn, and Solitary Working," Georgia van Raalte shares the legacy of occultist Dione Fortune and others. Naming Fortune as, "the first (modern, western) attempt to bring esotericism to women and the middle classes," van Raalte explores Fortune's complex philosophies in

relation to mothering and notes that the importance of family and motherhood have been lost from much of contemporary occultism. She argues that sexuality, motherhood, and family should not be considered separate categories. With the still sacrificial context of motherhood and the overly sexualized patriarchal imagination of the dominant culture, van Raalte proposes that the "truly revolutionary would be to position fulfillment in the space of 'hygge'—in contentedness, growth and family in order to highlight a more public role of family members."

The final book section, "Empowering Spirited Mother-Daughter Lineages," focuses on being a daughter and/or being a mother of daughters as well as the effects of Pagan and Goddess spirituality for family lineage, healing, and empowering women across generations. In "The Spiritual Dimension of Mother-Daughter Groups: Healing with Artemis, Demeter, and Persephone," Laura Zegel speaks of the power of the mother-daughter Goddess archetype of Demeter and Persephone for modern mother-daughter support groups. Zegel relates these mother-daughter Goddesses and their mythology to the growth of mother-daughter groups in her local community. She explores the generative impact of community groups to support mothers in empowering their daughters as they grow into adulthood.

Author Jennifer Lawrence follows with a poem titled "My Persephone." Lawrence explores her love for her daughter as they kneel together in the garden, where mothering a child is beautifully evoked as being like growing a garden, with prayers to Goddess Demeter for a daughter's safety and wellbeing.

In "The Thread. From Mother to Daughter to Grandmother: Mothers Talk to Their Daughters, from Mythical Times to the Birth of History," Arabella von Arx writes a fictional tale illustrated by hand drawings, told across generations of women who bear only daughters. Imagining those who might have been her own ancestors and how they bore their lives, von Arx spins a continuous, thread of wonders in the lives of the daughter, the mother, and the grandmother. Her stories explore the "collected the cares and sufferings and toils and brief moments of joy of the women to whom we owe our existence."

In "Goddess Is Mother Love," we, the coeditors, Nané Jordan and Chandra Alexandre, share a weaving of our own stories from the forefront of Goddess-centred homes. We interweave storied glimpses of our practices of Goddess spiritualty and the meanings and effects of such

upon the empowerment of our mothering lives.

Cory Ellen Gatrall closes the anthology with "Death and the Mother: Integrating Death into a Pagan Family Life," a loving look at the meaning of death from Pagan views. These teach the wisdom of the acceptance of death and the natural processes of grief as one encounters life's end, along with the importance of an open approach to death as part of life. Gatrall was born to atheistic parents to whom death was the cessation of life, and nothingness followed. She found meaning in Paganism and its acknowledgment of life's cycles, where death is honoured and importantly not spoken of with drama.

Cycling from birth to death and life in-between, through the richness of mothers living Pagan- and Goddess-centred pathways, we wish to thank our authors for their storied, creative, and scholarly contributions to this field. We hope this anthology sparks further spirited and matricentric feminist inquiries into Pagan and Goddess traditions. In the spirit of Mother Goddesses everywhere, we seek to keep matrifocal narratives and the importance of mothering at the forefront of our inquiries, where Goddess is the penultimate extension, expansion, and primordial Mother of the very notion of matricentric feminism.

Mother Goddesses—as deity, symbol, energy, form, culture, creative power, and practice—feed our daily lives as mothers and as people acting in the world towards social change and justice in public and family lives. We value the gift and potential of Pagan and Goddess spirituality to support and sustain new ways of empowering mothering for this generation and those to come.

Let there be beauty and strength, power and compassion,
honor and humility, mirth and reverence within you.
And you who seek to know Me,
know that the seeking and yearning will avail you not,
unless you know the Mystery: for if that which you seek,
you find not within yourself, you will never find it without.
For behold, I have been with you from the beginning,
and I am that which is attained at the end of desire.

(From *Traditional Charge of the Goddess* by Doreen Valiente,
adapted by Starhawk)

Works Cited

Adler, Margot. *Drawing Down the Moon: Witches, Druids, Goddess-Worshippers, and Other Pagans in America Today.* Arkana, 1987.

Ball, Caroline. "Wicca, Witchcraft, and the Goddess Revival: An Examination of the Growth of Wicca in Post-War America." *Goddesses in Myth, History, and Culture,* edited by Mary Ann Beavis and Helen Hye-Sook Hwang, Mago Books, 2018, pp. 413-33.

Baring, Anne, and Jules Cashford. *The Myth of the Goddess: Evolution of an Image.* Arkana, Penguin Books, 1991.

Budapest, Zsuzsanna E. *Grandmother Moon.* The Women's Spirituality Forum, 2011.

Christ, Carol. "Why Women need the Goddess: Phenomneological, Psychological, and Political Reflections." *The Politics of Women's Spirituality: Essays on the Rise of Spiritual Power within the Feminist Movement,* edited by Charlene Spretnak, Anchor Press/ Doubleday, 1982, pp. 71-86.

Daly, Mary. *Beyond God the Father: Towards a Philosophy of Women's Liberation.* Beacon Press, 1973.

Dashu, Max. *Witches and Pagans: Women in European Folk Religion, 700-1100 AD.* Veleda Press, 2016.

Eisler, Riane. *The Chalice and the Blade:* Our History, Our Future. HarperCollins, 1988.

Gadon, Elinor. *The Once and Future Goddess: A Symbol for Our Time.* Harper & Row, 1989.

Gimbutus, Marija. *The Language of the Goddess.* HarperCollins, 1991.

Goettner-Abendroth, Heidi. *Societies of Peace: Matriarchies Past Present and Future.* Inanna Press, 2009.

Grahn, Judy. *Blood, Bread, and Roses: How Menstruation Created the World.* Beacon Press, 1993.

Green, Fiona Joy. "Practicing Matricentric Feminist Mothering." Journal of the Motherhood Initiative, vol. 10, no. 1 & 2, 2019, pp. 83-100.

Hiltebeitel, Alf, and Kathleen M. Erndl. *Is the Goddess a Feminist: The Politics of South Asian Goddesses.* New York University Press, 2000.

Hwang, Helen Hye-Sook, et al., editors. *She Rises: How Goddess Feminism, Activism, and Spirituality.* Mago Books, 2016.

Jones, Kathy. *Soul and Shadow: Birthing Motherworld, the Healing Journey of a Priestess of Avalon.* Ariadne Publications, 2017.

Jordan, Nané. *Inspiriting the Academy: Weaving Stories and Practices of Living Women's Spirituality.* Unpublished doctoral dissertation, The University of British Columbia, 2011, circle.ubc.ca/handle/2429/39810. Accessed 21 Nov. 2020.

Jordan, Nané, editor. *Placenta Wit: Mother Stories, Rituals, and Research.* Demeter Press, 2017.

Kent, Tami Lynn. *Wild Feminine: Finding Power, Spirit & Joy in the Female Body.* Atria Books, 2011.

Ma, Vajra. "The Tantric Dance of Feminine Power in the Fourth Wave of Feminism." *Foremothers of the Women's Spirituality Movement: Elders and Wayshowers,* edited by Miriam Robbins Dexter and Vicki Noble, Teneo Press, 2015, pp. 225-234.

Noble, Vicki. *Shakti Woman: Feeling our Fire, Healing our World.* HarperCollins, 1991.

Reid, Donna. *The Burning Times.* The National Film Board of Canada documentary series, 1990.

O'Reilly, Andrea. *Matricentric Feminism: Theory, Activism, and Practice.* Demeter Press, 2016.

O'Reilly, Andrea. "Matricentric Feminism: A Feminism for Mothers." Journal of the Motherhood Initiative, vol. 10, no. 1-2, 2019, pp. 13-26.

Remer, Molly. *Brigid's Grove: Ritual Recipe Kit,* 2014, www.brigidsgrove.com. Accessed 21 Nov. 2021.

Robbins Dexter, Miriam, and Vicki Noble, editors. *Foremothers of the Women's Spirituality Movement: Elders and Visionaries.* Teneo Press, 2015.

Sjoo, Monica, and Barbara Mor, *The Great Cosmic Mother: Rediscovering the Religion of the Earth.* HarperCollins, 1991.

Spretnak, Charlene, editor. *The Politics of Women's Spirituality: Essays on the Rise of Spiritual power within the Feminist Movement.* Anchor Books, 1982.

Starhawk. *Dreaming the Dark: Magic, Sex, and Politics.* Beacon Press, 1997.

Starhawk. *Charge of the Goddess* (Traditional by Doreen Valiente, adapted by Starhawk). reclaimingcollective.wordpress.com/charge-of-the-goddess/. Accessed 21 Nov. 2020.

Stone, Merlin. *When God Was a Woman.* Harvest/Harcourt Brace, 1976.

Teish, Luisah. *Jambalaya: The Natural Woman's Book of Personal Charms and Practical Rituals.* HarperSanFrancisco 1988.

van der Meer, Annine. *The Language of MA: The Evolution of the female Image in 40,000 Years of Global Venus Art.* A3 Boeken Publisher, 2010.

Vaughan, Genevieve. *The Gift in the Heart of Language: The Maternal Source of Meaning.* Mimesis International, *Philosophy* n. 11, 2015.

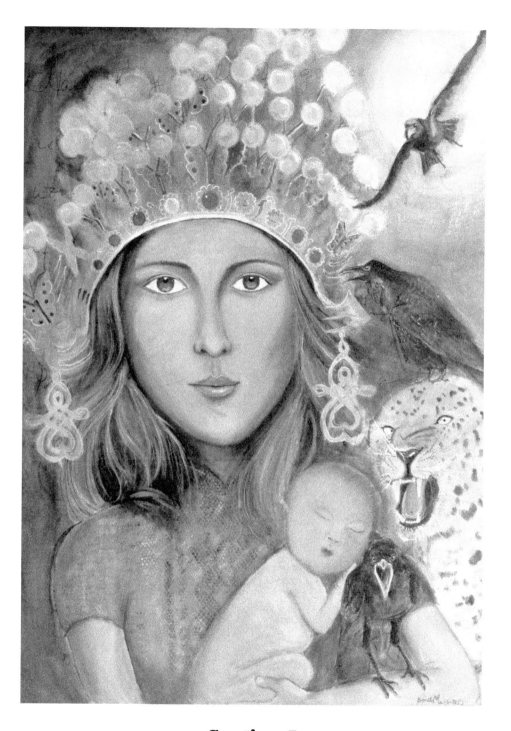

Section I

Priestess, Witch, Artist, Midwife: Mother Stories

Chapter One

Mamapriestess

Molly Remer

She who changes

She who expands and contracts

She who stretches her limits

She who digs deep

She who triumphs and fails

Every day

Sometimes both within a single hour

She who tends her own hearth

She who comforts and connects and enfolds

She who opens *wide*

She whose heart cracks open at birth

She whose tension bunches her shoulders

And lines her face

She who laughs

She who carries the world

She who sings with her sisters

And circles in ceremony

She who holds precious her daughters and her sons

She who defends and protects

She who opens her heart just a *little* wider

She who trusts

She who tries again

She who gathers to her breast

She who gathers women in ritual

She who hopes

Prays

Fears

She who loves *so deeply*

That it crosses all boundaries

To eternity...

In the book *Living in the Lap of the Goddess*, author Cynthia Eller notes that "Some spiritual feminists say that having a divine mother is a way of compensating for the frailties of human mothers, giving women a more perfect mother" (143). This is not actually true for me; I am fortunate enough to have an excellent human mother. However, I do see myself as a mother reflected in the empowering imagery of the Goddess as mother. I feel as if she affirms my worth and value in my own maternal role. She gives me strength and inspiration to be a better mother to my children. In this way, I agree with the hope of spiritual feminists that this "great mother goddess will have a transformative effect upon the social valuation of motherhood" (Eller 143).

I am also of the opinion that Mother Goddess imagery may well be less about women as mothers and more about the motheredness of the world. I do not find the image of the Mother Goddess to be exclusive; rather, I find it exceedingly appropriate. Since the dawn of time, every person and mammal on this planet—male, female, Black, white, gay, straight—has had a mother. It is a truly unifying feature. And it is not about the role; it is about the primal relationship—the root of life. While reflecting on an ordinary street scene and suddenly understanding the web of life and the universality of motherhood (even the squirrels), Naomi Wolf writes the following:

> We were all held, touched, interrelated, in an invisible net of incarnation. I would scarcely think of it ordinarily; yet for each creature I saw, someone, a mother, had given birth.... Mother-

hood was the gate. It was something that had always been invisible to me before, or so unvalued as to be beneath noticing: the motheredness of the world. (102)

This understanding of the invisible net of incarnation is the foundation of my own thealogy and my ethics. In his book *Goddess as Nature: Towards a Philosophical Thealogy*, Paul Reid-Bowen states the following:

"The model of the mother may prompt reflection on the idea that everything emerges from, exists in a relationship to, and is often dependent upon something existing prior to it (a mother, world, nature or Goddess).... For thealogians, the model of the Mother is a powerful means of drawing attention to the bodily realities, connections, dependencies, and relationships that shape not only human life but the whole of existence. (66)

Reid-Bowen goes on to quote Naomi Goldenberg: "Since every human life begins in the body of a woman, the image of woman, whether thought of as mother or Goddess, always points to an early history of connectedness: Mother-*mater*-matter-matrix. 'Woman' is the stuff out of which all people are made" (66). Goddess as creatrix of the world, to me, is of much deeper and more primary significance to me than the Goddess as a fertility figure, as so often described in nonthealogical discourse.

The sociocultural value of a divine presence that validates women's bodies cannot be overestimated. Indeed, patriarchal religion in its most destructive way seems to have grown out of the devaluation and rejection of female bodies. A religion that rejects the female body—one that places the male and its association with the mind and the soul rather than the earthy relational connection of body—is a religion that can easily lead to the domination and control of women. Reclaiming the Goddess, reclaims women's bodies; it names them not only as normal but as divine, and this is profoundly threatening to traditional Judeo-Christian belief systems. Thus, the primacy of relatedness and connectedness as the core feature of the Mother Goddess model has broad reaching implications for women's spirituality, as a direct contrast to the dominator model of patriarchy.

In Carol Christ's classic essay, *"Why Women Needs the Goddess,"* she quotes feminist theologian Mary Daly from her text *Beyond God the Father*:

If God in "his" heaven is a father ruling his people, then it is the "nature" of things and according to divine plan and the order of the universe that society be male dominated. Within this context, a mystification of roles takes place: The husband dominating his wife represents God "himself." The images and values of a given society have been projected into the realm of dogmas and "Articles of Faith," and these in turn justify the social structures which have given rise to them and which sustain their plausibility. (2)

In the same essay, Christ also explains the following:

The symbols associated with these important rituals cannot fail to affect the deep or unconscious structures of the mind of even a person who has rejected these symbolisms on a conscious level.... Symbol systems cannot simply be rejected, they must be replaced. When there is not any replacement, the mind will revert to familiar structures in times of crisis, bafflement, or defeat. (2)

I notice this among some friends and family members—while not identifying as Christian or religious, they may turn to Christian phrasing or symbolism to express ineffable concepts. They have no other language or framework for explaining their experiences or ideas.

It is important to me that my children, particularly my sons, are being raised in a home in which female connection to divinity is normal and that Goddess images are all around them. I hope that their default symbol and system of belief as adults will, therefore, include the Goddess, regardless of how their individual spiritual paths develop. As an example, I have a book for children called *Big Momma Makes the World*, in which a full-figured, practical-looking woman holding a baby on her hips creates heaven and earth and everything in between, and "It was good, it was real good" (14). I love that my sons are growing up with this sort of imagery about creation. For me, Goddess religion and spirituality is as much about sociocultural valuation (or devaluation) of women and making a feminist political statement as it is about lived experience. Both are very valuable to me.

In her amazing essay, "Towards a Womanist Analysis of Birth," Arisika Razak speaks boldly about the significance of birth to the health of the planet:

The real plague that threatens us is our attitude toward one another. Why is birth not considered a major psychic event? Where is our birth art? Where are our birth stories? Why don't we celebrate birth instead of war? Why do we restrict fathers from participation in birth? If we begin with loving care for the young, and extend that to social caring for all people and personal concern for the planet, we would have a different world. If we understood, and celebrated birth, we'd seek more humane alternatives to painful medical processes—we'd reclaim the importance of love and warmth and human interaction.... In a society that wishes us to see men as devoid of feelings, let us hold an image of men as nurturers. Women are birth-givers, but men can care with them. Let us change our institutions. Let us demand that men come with us. Let birth teach them surrender. Let pain teach them transcendence. Let the shared experience of childbirth reclaim the human soul. (172)

<div align="center">*</div>

It is late autumn, 2009. I am thirty years old and pregnant with my third baby. He dies during the early part of my second trimester, and I give birth to him in my bathroom, on my own with only my husband as witness. The blood comes, welling up over my fingers and spilling from my body in clots the size of grapefruits. I feel myself losing consciousness and am unable to distinguish whether I am fainting or dying. As my mom drives me to the emergency room, I lie on the back seat, humming: "Woman am I. Spirit am I. I am the infinite within my soul. I have no beginning and I have no end. All this I am." I do this so that my husband and mother will know I am still alive.

I do not die.

This crisis in my life and the complicated and dark walk through grief is a spiritual catalyst for me—a turning point in my understanding of myself, my purpose, my identity, and my spirituality.

It is my thirty-first birthday. May 3rd. My baby's due date. I go to the labyrinth in my front yard alone and walk through my labour with him— remembering, releasing, letting go of the stored-up body memory of his pregnancy. I am not pregnant with him anymore. I have given birth. This pregnancy is over. I walk the labyrinth singing, and when I emerge, I make a formal pledge, a dedication of service and commitment to the Goddess. I do not yet identify myself verbally as a priestess, but this is where the vow of my heart begins.

I do not know at the time, but less than two weeks later, I discover I am in fact pregnant with my daughter, my precious treasure of a rainbow baby girl who is born into my own hands on my living room floor the next winter. As I greet her, I cry, "You're alive! You're alive! There's nothing wrong with me!" And I feel a wild, sweet relief and painful joy as I have never experienced before.

*

In *Women of the Sacred Groves: Divine Priestesses of Okinawa*, anthropologist Susan Starr Sered presents her in-depth research on a small coculture on the island of Okinawa. She notes that most of the Japanese priestesses on the island became priestesses after a shamanic type of illness and healing crisis. More specifically, it was not that they truly became; priestesses then; it was that the illness or crisis allowed them to discover or realize what they had really been all along. She additionally notes that some of them would become sick while actively resisting the call to priestesshood and then be healed once accepting themselves as priestesses.

These experiences were catalysts; they defined life moments and initiatory experiences, which opened doors and illuminated paths for these priestesses through their physical bodies.

When I was pregnant with my first baby, I read an article with the theme of birth as a shamanic experience. I can no longer find the exact article, but I distinctly remember my feeling upon reading it—I was entering into a mystery. Giving birth was big; it was bigger than anything I'd ever done before, and it went beyond the realm of a purely biological process and into something else. Like shamanic experiences, giving birth is often described as involving a sense of connection to the larger forces of the world as well as being in an altered state of consciousness or even a trance state. Although shamanic experiences may involve journeying to other realms of reality, giving birth requires the most thoroughly embodied rootedness of being that I have ever experienced. It, too, is a journey, but it is a journey into one's own deepest resources and strongest places. The sensation of being in a totally focused, state of trance and on a soul work mission is intense, defining, and pivotal. Midwife Leslene della-Madre describes such an experience:

> Birth is certainly messy and bloody. It is intense, fierce, fiery and loud, but not violent. It is bloody from shamanic transformation.

Birth-blood is the primordial ocean of life that has sustained the child in utero; the giving of this blood in birth is the mother's gift to her child. The flow of blood is the first sign, following the flow of waters, that signals that new life is on the way, just as it is the first sign of a young maiden's initiation into a new life at her menarche. The blood of transformation is miraculous. In Spanish, the phrase "dar a la luz," to give birth, literally means "to give to the light." Giving to the light—mothers giving birth are giving light to new life through blood. The messiness and bloodiness of birth are the gift of the Earth–elemental chaos coming into form.

In the aftermath of giving birth, particularly without medication, many women describe a sense of expansive oneness—with other women, with the Earth, and with the cycles and rhythms of life. People who become shamans, usually do so after events involving challenge and stress in which the shaman must navigate tough obstacles and confront fears. What is a laboring woman but the original shaman—a "shemama" as Leslene della Madre would say—as she works through her fears and passes through them, emerging with strength.

After explaining that the homebirth of her second son was her "first initiation into the Goddess ... even though at that time I didn't consciously know of Her" (132), Monica Sjoo, writing in an anthology of priestess essays called *Voices of the Goddess*, explains further:

The Birthing Woman is the original shaman. She brings the ancestral spirit being into this realm while risking her life doing so. No wonder that the most ancient temples were the sacred birth places and that the priestesses of the Mother were also midwives, healers, astrologers and guides to the souls of the dying. Women bridge the borderline realms between life and death and in the past have therefore always been the oracles, sibyls, mediums and wise women ... the power of original creation thinking is connected to the power of mothering. Motherhood is ritually powerful and of great spiritual and occult competence because bearing, like bleeding, is a transformative magical act. It is the power of ritual magic, the power of thought or mind, that gives rise to biological organisms as well as to social organizations, cultures and transformations of all kinds. (132)

I spent more than ten years as a childbirth educator and gave birth five times. Each birth brought me the gift of a profound sense of my own inherent worth and value. It was the shamanic journey through the death-birth of my tiny third child, however, that ushered in a new sense of my own spirituality and that involved a profound almost near-death experience for me. After passing through this intense, initiatory crisis, the direction and focus of my life and work changed and deepened. Shortly after the death-birth of my third son, I wrote:

> Though my miscarriage was the most difficult and saddest exper-
> ience of my life, I feel like it was a profound and transformative
> and actually sacred experience. I am so grateful to my little Noah
> and for the gifts he brought to my life. His birth has taken its
> place as the most transformative experience of my life. I feel like
> I am still in this place of "openness" after birthing him, where I
> am ripe for growth and change and discovery…. I feel like I can
> appreciate more fully the totality and complexity of the female
> experience/life as a woman. ("Open to Change")

I feel I actually encountered the Goddess most meaningfully during this time of personal suffering. Although I previously connected strongly with Goddess imagery and was interested in Goddesses and women's spirituality from a feminist perspective that valued the symbolism in a socio-political context, I did not feel a truly personal experience of Goddess energy until this pregnancy loss. That is when I felt She actually existed and when I realized that I was in relationship to her all the time. When being transferred to the hospital singing the "Woman Am I" chant to let my husband and mother know I was still alive, I did not feel scared of dying because I felt a compassionate presence, which I concluded could be defined as "Goddess." And, in the aftermath of this tiny son's birth, I felt accepting of myself in a way I had never felt before: a sense of being held and a sense of profound worth, something perhaps similar to the "ground of being as love" that Carol Christ describes in her writings (*She Who Changes* 106). I was also amazed to discover that after years of self-defining as a-religious, I did in fact have a spiritual language and conceptualization of my own and that these were the deep resources I gathered to me during a time of significant distress, fear, and challenge.

Following the miscarriage birth of this baby, I experienced another early miscarriage at six weeks and then went on to become pregnant

with my daughter. The courage required to keep going and to try again after such a traumatic loss is a touchstone I have drawn upon for strength ever since. It is powerful to feel fear and then do it anyway. It is powerful to watch yourself move through crisis and emerge with strength. It is courageous to move within fear—to feel it, to sit with it, and to move within it. As I moved through the early weeks of her pregnancy, I realized that while I had longed to restore my rightful state as Pregnant Woman, I felt disconnected from the physicality of being pregnant again. I felt as if I needed to actively and purposefully reincorporate the pregnant identity into my sense of self. I turned to birth art, creating the first of what would become an ongoing, life-changing process of three-dimensional journaling, making clay goddess sculptures about my life and feelings. To welcome Pregnant Woman back into my heart, soul, and identity, I created a full-figured golden sculpture of a pregnant goddess and as I worked on her, I began to settle back into the feeling and connection of being pregnant again. She sat on my altar until my new baby girl was safely born and held close to my heart. Another small pregnant goddess figure journeyed with me into the birth pool as I laboured and gave birth to my final child, another boy, my first unexpected pregnancy, which prompted a journey through opening my heart, mind, and body to what is unplanned. As I look at the curly head of my young daughter and the golden hair of my final baby, I give thanks to their brother, and to Her, the Goddess, for opening the way that they may enter this world.

Each of my clay goddess figures either had a message for me or was created to express a message or a lesson or to incorporate some aspect of my identity or to capture a memory. From here, I expanded to create many different goddess sculptures that represented many different identities, goddesses, and paths. I also created several mamapriestess figures, which encompass the balance of priestessing my community and priestessing my own hearth.

*

The moon is full. My newborn son is one week old. We bring him outside for the first time in his whole life to meet the world, to feel the fresh, cool air, and to be introduced to the moon and the Earth as a member of our family. Each family member carries a candle outside into the full moon's light. We hum together to cast our circle and place our hands on the new baby.

Welcome to the spinning world, baby boy!
Welcome to the green Earth!
We're so glad you're here!

We each choose a piece of corn from a chalice and make a wish aloud
for the baby, tossing the corn into the moonlight and then hold the baby out
under the moonlight. He stares right at the moon with solemn, wide eyes.

We join hands and say this prayer:
May Goddess bless and keep us,
may wisdom dwell within us,
may we create peace.

<p style="text-align:center">*</p>

While writing my dissertation on contemporary priestessing in the United States, I read Nicole Christine's intensive, detailed priestess memoir, *Under Her Wings.* In so doing, I kept thinking, *"But I want to hear from the mamapriestesses, from the hearth priestesses. Where are the other practicing priestesses with children at home?"* I noticed in Christine's book that the bulk of her work took place *after* her children were grown, and, to my mind, she also had to distance or separate from her children and her relationships in order to fully embrace her priestess self. I noticed in my reading and my dissertation research group that many women seem to come to priestess work when the intensive stage of motherhood has passed, *or* they do not have children. Is there a very good reason why temple priestesses were virgins and village wise women were crones? Where does the mamapriestess fit?

As I read Christine's book and witnessed her intensive self-exploration, discovery, and personal ceremonies and journeys, I realized that in many ways, personal exploration feels like a luxury I do not have at this point in my parenting life. How do we balance our inner journeys with our outer processes? Christine references having to step aside and be somewhat aloof or unavailable to let inner processes and understandings develop, since our inner journeys may become significantly bogged down in groups by interpersonal relationships, dramas, venting, chatting, and so forth. For me, this distance for inner process exploration is not possible in the immersive stage of life as a mother. Yet I also know in my bones that I am not meant to give it up.

In researching historical roles of priestesses, I notice many mentions of unmarried "temple virgins," who served as priestesses until they married and had families. Or there is the wise woman priestesses, whose

children are grown and out of the home. I asked my dissertation research group: How do you balance this? How does it work for you? Parenting, for me, can simultaneously feel as if it is stifling my full expression yet, perhaps, holds the greatest lessons.

I appreciate the acknowledgement by Joan Connelly in *Portrait of a Priestess* that, historically, priestesses fulfilled multiple complex roles and did not likely act exclusively as priestesses. She writes as follows: "Life-long priesthoods were typically held by married women leading 'normal' lives, complete with husbands and children. Greek religious offices were enormously practical, enabling women to serve at each stage of life without sacrificing the full experience of marriage and motherhood" (18). Since I am a mother, professor, writer, and artist, as well as a priestess, I found this an important historical affirmation.

Several of the wise women I interviewed for my dissertation found that they had to fulfill both roles simultaneously. One explained that priestess-parenting has to take place in bits and pieces rather than an unbroken stream: "Priestess-parenting is hard work. It is never-ending and provides extraordinary opportunities for introspection, evaluation, growth, creativity. However, it comes in bits and pieces" (109).

Although I have termed it "priestess of my own hearth," another participant described it as a "priestess of the cauldron," a description that spoke to my heart: "I believe that in the cauldron of family life, I am and was being more fully formed as priestess. Undergoing the changes which being mother brought about, is the transformation in the cauldron. Perhaps mamapriestesses are—at the root—priestesses of the cauldron" (109).

Another mamapriestess with a very young child thoughtfully responded:

> I've been reflecting on this last year, and I've realized that I've learned more in this year about womanhood, motherhood, family, love, and myself than any prior year if my life. That IS the Goddess working in my life! I may have been so deep in it that I lost the forest for the trees, but a little self-reflection helped me to realize that I still am in constant contact with Her. She still teaches me and helps me though each lesson. It's just these are no longer the lessons of the Maiden; these are the lessons of the Mother and these lessons are learned by living not by thinking. In this way, every mother is a priestess. (110)

I feel the priestess is integral to my bones. I cannot not be her, even if I wonder if it is the right stage of my life for this work. Another priestess expressed the same certainty that her priestesshood is an integral part of herself:

> I feel that priestessing is an integral part of myself. I could no more separate that part of me than I could separate myself from motherhood. And I believe that I am not supposed to. I always knew I wanted to be a mom. I had a list of twenty-one names from my adolescence that I saved (I still have it) because that's how many children I wanted. I have eight and am considering another…. One day my children will be grown and out of the house, and I will know that have accomplished much priestessing in the process of raising them. I think that I may always be a mother (there are many ways to mother, whether it involves one's own children or not) just as I will always be priestess. (110)

This interweaving and understanding of the how our many roles intersect to form the fabric of our individual complex, multifaceted lives is important. Parenthood can also ignite one's personal spiritual path, as it did for me.

What would the mamapriestess tell me if I would stop long enough to pay attention to her? She would tell me, "Babies are your teachers too, mama. Listen to the baby." In his smile, you just may meet the Goddess. In the pull and twist between tasks, you may uncover the heart of Zen. In the giving of your body and your blood made into milk to sustain the life of another, you may discover what it means to be a Goddess. As you wrestle with flexibility, surrender, and change, you may come face to face with both your shadow and with the very heart of the human experience and the priestess path.

Several years ago, as I worked on a new sculpture, my six-year-old son worked at the table too and presented me with a special gift of his own design. "This is the Goddess of Everything," he told me. "See that pink jewel in her belly; that is the whole universe, Mom!!"

Works Cited

Christ, Carol. "Why Women Need the Goddess." *Womanspirit Rising: A Feminist Reader on Religion*, edited by Carol Christ and Judith Plaskow, Harper & Row, 1979, pp. 273-287.

Christine, Nicole. *Under Her Wings: The Making of a Magdalene.* Author House, 2005.

Connelly, Joan. *Portrait of a Priestess.* Princeton University Press, 2009.

della-Madre, Leslene. "Birthing as Shamanic Experience." *Midwifing Death,* www.midwifingdeath.com/musings/birthing_as_shamanic.html. Accessed 6 June 2013.

Eller, Cynthia. *Living in the Lap of the Goddess: The Feminist Spirituality Movement in America.* Beacon Press, 1995.

Frasier, Debra. *On the Day You Were Born.* HMH Books for Young Readers, 2006.

Reid-Bowen, Paul. *Goddess as Nature: Towards a Philosophical Thealogy.* Routledge, 2016.

Remer, Molly. "Open to Change," *Footprints on my Heart,* 26 Jan. 2010, tinyfootprintsonmyheart.wordpress.com/2010/01/26/open-to-change/. Accessed 22 Nov. 2020.

Remer, Molly. *The Priestess Workbook.* unpublished dissertation manuscript, 2016.

Root, Phyllis. *Big Momma Makes the World.* Candlewick, 2007.

Razak, Ariska."Towards a Womanist Analysis of Birth." *Reweaving the World: The Emergence of Ecofeminism,* edited by Gloria Orenstein, Sierra Club Books, 1990, pp. 165-72.

Sered, Susan Starr. *Women of the Sacred Groves: Divine Priestesses of Okinawa.* Oxford University Press, 1999.

Sjoo, Monica. *Voices of the Goddess: A Chorus of Sibyls,* edited by Caitlin Matthews, Thomas Publications, 1990, pp. 123-49.

Wolf, Naomi. *Misconceptions: Truth, Lies, and the Unexpected on the Journey to Motherhood.* Anchor, 2003.

Chapter Two

Finding My Footing as a Witch and a Mother

Sarah Rosehill

The room was quiet for a sudden moment. Into the silence, my doula said, "What would you like to have happen?"

I'd just yelled at my midwife, two undoubtedly nice nurses, and my entire birth team to stop telling me what do. It was nearly forty-eight hours after I'd been given the first drugs meant to usher my daughter from inside my body into the outside world, and in those two days, I'd given up dream after dream—the vision of a natural labour or, at least, a drug-free one or, at the very least, a labour where I was allowed to move off my goddamned side. I'd moved through time in a litany of interventions and measurements: Cytotec, monitor, IV, terbutaline, Cervidil, one centimetre, foley balloon, morphine, three centimetres, epidural, catheter, internal monitor, eight centimetres, Zofran, rectal pressure, bolus.

"Let me try it my way," I sobbed, before my next contraction started. After that, I only remember snapshots. Contractions coming so fast that I felt like I could barely breathe. Absolute certainty about where the baby was in my body and a vague surprise that it was so much like the way it looked in diagrams. Reaching down and touching her head while it was still inside me. My doula saying, "I guess her way works." Not even feeling the shock of my emptiness before my daughter was on my chest.

Five days earlier, I'd gone to my midwives for a routine checkup. The nurse had taken my blood pressure and told me to relax for a few minutes and she'd check it again. Then my midwife took it and casually asked if my hospital bag was in my car. It was. They hooked me up to a monitor

and assured me the baby was perfectly fine. "I'm not ordering bed rest," my midwife said, "but stop working." She continued, "I don't want you to do anything as strenuous as grocery shopping." Then she sent me over to the hospital, where I was hooked up again to both a blood pressure monitor and a fetal one. They drew blood, took more urine samples, and consulted the high-risk OB-GYN.

I spent three days gaining brief reprieves: they would send me home from the hospital or call with test results and say they didn't have to induce right then. The on-call midwife would recite the list of symptoms for which I should come in immediately: floaters in my vision, headaches, abdominal pain, and shortness of breath. And then they would tell me we would reconsider in twelve hours, or twenty. The whole thing felt surreal, waiting for some symptom or test result that would make one of these reprieves the last. And then it was.

Everyone says you cannot know what to expect when you have a child, and this is, of course, perfectly true. My own terror, before my daughter was curled on my chest as if she'd never been anywhere else, was that I would be exhausted, strung out, without anything to give to a tiny human who would, in some very concrete ways, need only me. This turned out to be as false as my vision of a labour unfolding at its own pace.

My daughter—who is sixteen months as I write this and full of newly expressible desires—has turned out to need me and only me with an intensity I never anticipated. For ten weeks, she was never happy for more than twenty-five minutes unless she was in someone's arms, even when asleep. By six weeks, she disliked being held by strangers, a position she has yet to reverse. And even when fed and dry and attended to by her adoring grandparents, she still, often enough, just wanted mama.

I am many things: a feminist, a person with friends and lovers, and someone who is deeply committed to my communities. And, somehow, I turned out to want nothing more than to have my baby curled in my arms.

In Pagan circles, pregnancy is often described as magical, and, to be fair, there isn't much more obviously miraculous than a whole new person being made. Despite this, I would choose other words to describe my pregnancy: exhausting, overwhelming, and maybe even painful.

I started saying that my pelvis hurt at fourteen weeks. By thirty-two

weeks, any kind of movement hurt: standing, sitting, rolling over. So, there was that. And then there was Milo, my daughter's twin, and the other baby—the one whose heart I saw flickering on three beautiful ultrasounds before it stopped. The announcement of Milo's presence inside me turned my world upside-down—twins! But the announcement of his death, just five weeks later, tore it apart. Fourteen weeks later, the loss of my marriage followed, like a ship sinking slowly but inexorably under the waves.

All this material loss felt absolutely real. What felt unreachably distant was my spiritual practice. The kind of magic that I heard described in stories both personal and mythological was specific—a kind of softly backlit, archetypically feminine power, the life-giving Earth Mother, the Empress in the Tarot, serene and assured. My pregnancy didn't feel at all like a twilit field of flowers. It felt like a riptide that yanked me under, dragged me from shore, and tossed me, exhausted, a long slog from home.

One of my traditions, Feri, has beautiful imagery of mothers and goddesses. It tells of the Star Goddess who birthed the universe and all the bright spirits within it through an act of self-love. It describes the divine aspect of the self as a perfectly loving parent, and we pray "Holy Mother... from you all things emerge and unto you all things return." While I was trying to get pregnant, which turned out not to be very straightforward, all of this imagery felt deeply evocative, but once there was a tiny human growing inside of me, it suddenly lost its resonance and felt impersonal and abstract.

*

Anamanta, my other spiritual tradition, invites us to open to the world around us—the earth, the wind, the lake, the stars—but I didn't want to. I just wanted to show everything to the baby: "Look, here's the earth, and there are the stars. This is the lake; it's cold, see? When you are bigger, you can swim in it."

A few months after I had my daughter, I briefly considered writing an essay titled "Confession: I'm a Single Mother with a Tiny Infant and I Am Happy." There are so many essays describing the horrors of early parenthood that it felt like some kind of dirty secret. I listened to people in my new moms' group describe missing their prebaby lives, leaving their babies with people for yoga class or to get a manicure, and I felt like

someone observing a foreign culture.

When it comes to romance, our culture believes in maintaining individuality, boundaries, and selfhood. And this same language prevails in many discussions of parenting. You balance your needs with the baby's. You take time for yourself. Or, in certain circles, you always prioritize the baby's needs. None of this seemed to me to apply because nothing in me understood her needs as separate from mine. I don't mean to paint these days as uninterrupted bliss. There were plenty of times that I started counting down to naptime as soon as I woke up. I read countless books in the Kindle app on my phone while walking back and forth around my five-hundred square foot house at 2:00 a.m., trying to get my daughter back to sleep. I had nightmares and crying jags. What surprised me was that I didn't resent any of this.

The one thing I did resent was having to return to work. This fact was clear to me by the time my daughter was only a few weeks old, and it contradicted everything I had assumed about who I would be as a mother. I had fully expected to join the ranks of working mothers who breathe a sigh of relief at the Monday morning drop-off, hungry for adult conversation, uninterrupted cups of coffee, and concrete accomplishments. Instead, I was the mama who started counting down the time until pickup before that first cup of coffee was finished and the one who lingered five minutes too long at drop-off every morning to give one more kiss—and another and another and another.

A pregnant friend recently asked me, "When did you feel normal again?" I told her the truth: "Never, and I don't want to." But I also tried to map out the milestones I passed in the first year. These events were as real as my daughter's first smile but harder to pick out as they were happening. There was the moment when nursing got easier and the one when I finally got a handle on our leaving-the-house routine, both around two months). Then I regained the ability to think about something other than the baby for an hour (six months) or to remember a three-item grocery list (not until she slept through the night at nine months). The moment leaving her with a sitter to do something fun started actually sounding like fun didn't come until twelve months, or about three days after she learned to say "no."

I told my friend that everything feels like two steps forwards and one back and that some weeks I hand in a work project and finally clean my sink and other weeks I spend two solid days rocking a feverish kid. I told

her about how the first rule of car trips with babies is to give up on the idea that you know when you'll arrive and how figuring this out made my life wildly less stressful. I also told her that every cliché she has ever heard about how much mamas love their babies is both true and utterly inadequate to the task of describing motherhood.

I came into adulthood steeped in my Anamanta tradition. At its core, Anamanta teaches that a spiritual path brings us from fear into ecstasy— the experience of union and deep connection. In Anamanta, the primary tools for doing this involve stripping away our preconceptions about what is essential to making something a tree, a raindrop, or a Sarah Rosehill in order to experience it as directly as possible. Nothing could have prepared me better for motherhood.

One of my Anamanta teachers, Andras Corban Arthen, says that spiritual practice is like carving a channel through rock with water. You send a trickle down across the rock the same way over and over and over again, and, eventually, it makes a path. When there is a flood, he says, the channel will hold.

For me, coming into being a mama as a single parent was a flood. It meant changing nearly everything about my day-to-day life. Logistically, a million things that I did before became impossible, including big things—like being in the office forty-plus hours a week or having dinners with friends—but also tiny, ordinary ones, like making plans and keeping them. But the yardsticks I used to measure my own value had to change too. My spiritual practice, even when I wasn't actively engaged with it, was the source of the tools that allowed me to make this shift with a modicum of grace. Those tools allowed me to soften and yield to inevitable changes, from the ones that brought my daughter out of my body to the ones that keep her safe and happy today. They helped me be present with the reality of parenting—even when that reality was that we were both crying—and to remember that even the hardest parts of her infancy would be gone too soon.

Now my daughter is a toddler. She scoots around and talks constantly about owls and elbows. Although she still hates for me to leave her, she recovers much more quickly. She also sleeps through the night most of the time and can entertain herself for several minutes by flipping through the pages of her books looking for moons. I, in turn, am often able to make a plan and keep it. I have started planning rituals again. In my spiritual practice, I've given up elaborate altar-based rituals in favor of

simple deep breaths, but this simpler practice still sustains me and connects me to myself, my daughter, and the earth.

When I first started teaching workshops, I focused on daily practice. For me, one of the things that Paganism offers is an alternative to Western mainstream culture, as it focuses on interconnection and the sacredness of the natural and physical worlds. But to give that worldview power, we have to live it, and daily practice seems important to me as a way of nourishing the deep roots of spirituality.

It's also a topic plagued by an ever-present set of tensions. What do we do and why? How do we commit to a practice with integrity but without descending into self-flagellation? Can our practice be integrated into our daily lives, or does it need to be set aside in dedicated time? Much of my most intense spiritual work has been of the set-aside variety, from the complex altar and circle practice of my Feri work to the hours my Anamanta practice group spend out in the woods. This kind of practice is sexy—it feels intense, even all consuming. For me, it was the kind of practice that helped me make my way through some of the most difficult experiences of my past and that allowed me to experience expanded states of awareness in a deep and sustained way, and these things were tremendously valuable to me.

It wasn't until I had a baby that I came to place equal value on the truly ordinary practices. A yogi friend once told me that there are two kinds of people who take beginner classes: beginners who need them, and teachers, who can get what they need from any class. For me, it wasn't arm balances but softness that it took years to cultivate. My twenty-year-old self's harsh judgment of what a good practice looked like turned out to be yet another thing to let go of. I know that this phase when my daughter is little, nursing, and mama-focused like nobody's business is only a season, and in this season, my practice is, as a wise mama friend says, to do what needs doing. When my daughter wants to nurse, I nurse her, even if it's not very convenient or I'm trying to do something else or we're in the middle of a ritual. I change diapers and wash sippy cups and sing song after song after song.

In the morning these days, I bring my daughter into bed to nurse. For some number of minutes, she still curls against my side, the only time she'll be this still all day. Even then, her top hand reaches around and pats the blanket, my face, and her hair. Then she declares "All done!" and "Outside!" which means that it's time to look out the window next to the bed.

"Good morning, sky," I say, pointing. She looks.

"Good morning, garden."

"Good morning, swamp."

"Good morning, trees."

"Good morning, leaves."

"Good morning, grass."

"Good morning, ground."

Chapter Three

Remothering and the Goddess

Asia Morgenthaler

One can choose to ignore Her call, as I did earlier in my life, or follow Her guidance and take the descent. I heard a loud cry when I became a mother, but, in reality, it was a summons from the Goddess to delve deep into myself. The Goddess communicates in different ways, and the descent takes on a form unique to each individual. Motherhood initiates women into the role of the Mother-Creator, calling them to uncover their genuine self, buried under today's cultural conditioning. The responsibility of raising your outer child can be seen as an opportunity for self-exploration, self-discovery, self-love, and, conceivably, an opening to remothering your own inner child.

My journey began with my first painting in my Art as a Sacred Practice class in my first semester of the Women's Spirituality Program for my Master of Arts; Goddess images flowed through me. I felt called to paint, even though I had no idea where that doorway would lead, but I remained open, receptive, and in deep inquiry. Art is a powerful medium that has often been used by religious institutions to manipulate people. From Eve's inimical portrayal in Genesis to that of the demure, accepting Virgin Mary, mothers have been depicted as sinful, weak, and beneath males. Many women have grown up believing, consciously or subconsciously, that they are less than men and judge themselves through the eyes of men. When these women meet their baby girls and see their babies whole and complete, they begin to question the validity of long-held beliefs that women are somehow less than men. When we engage

with creativity, we are embodying the creative facet of the Goddess, as we explore and bring our inner voice and expression into form. Even though art and creativity can be usurped as a medium for control and manipulation, we can, instead, utilize it for exploration and trans-formation. As makers, we become aligned with all creations, and we emerge as the antithesis to the passive consumers society manipulates.

At an early age, I learned that my wellbeing rested upon not jeopardizing my father's outwards face—that is, a person's reputation and feelings of prestige within the personal, business, and societal spheres. I can still hear my father's voice upon seeing my six-year-old self wearing a bareback dress at an Easter event: "People are going to think I don't make enough money to feed my daughter!" In other words, he would lose face because I was too skinny, which made me start a fattening regiment, only I gained too much weight. Then I was shamed for being fat, another reason for losing face. A person's face is evaluated not only on the person's worth but also their family's behaviour and appearance. I was forced, with my arms flailing and feet kicking, to become the reflection of the perfect child in order to preserve my father's face, which dictated how I should look and act, effectively defining my identity and how I should lead my life.

My father's primary concern rested in managing his face; in contrast, my mother was absent both emotionally and physically. I was raised by nannies during the week and was chauffeured to my grandmother's on the weekends. My parents were not interested in who I was, what I wanted, or how I felt. My role was to fit into what they perceived others or society would deem respectable or to gain face for the family. We operated on the "Kids should be seen but not heard" motto. The part of myself I now call my inner child was simply not good enough. She was ostracized before I ever got to know her.

I remember a distinct moment soon after my thirteenth birthday when I decided to abandon my desire to gain my parents' approval. I raged against them by hardening and rebelling. I was so exasperated and angry; it did not matter what I was doing as long as it was the exact opposite of what my parents wanted. All I needed was for them to feel my pain. I reversed course and took a turn down a completely different path. I broke out of the mould, the pieces scattered on the ground. But I was indifferent about finding myself among the debris.

In college, I majored in computer engineering because of a single

comment made about girls not being smart enough to be engineers. I was so disconnected from who I was that I led my life oscillating between doing the right thing and rebelling by doing the complete opposite. When I was in graduate school, I discovered ceramics. I would spend six to seven hours in the studio, completely absorbed with what I was doing. I heard an inner whisper to switch from computer science to visual arts, but I quickly dismissed that voice as being impractical. After graduation, I read all the *What Color Is My Parachute* type books that I could find— self-help books designed for those who need help finding themselves and their vocation. I had no idea who I was, and I would spend most of life trying to find the little girl in me that had been banished growing up. That is, until I became a mother. Motherhood was a profound rite of passage for me, as holding my baby girl for the first time was a huge wakeup call. I love being a mom, yet I felt I lacked a role model, so my search for strong female mentors began. I encountered many and appreciated what each had to offer. During my search for maternal role models, I remember wishing I had a mother like them when I was growing up.

My little family of three was standing in the back of the church during Christmas mass when my then two-and-a-half-year-old daughter tugged at me; her little index finger pointed at the statue of the Virgin Mary, and she whispered excitedly "Mama! Mama! Mama!!" My little girl had never called anyone or anything else mama except me. She recognized the Mother of God, the Heavenly Queen as mama. I was stunned but unsure what was revealed through that recognition. Despite growing up Catholic, the Church and its teachings never resonated with me; the demure images of Mary did nothing for me. As Kathie Carlson relates from: "[The Virgin Mary] no longer represents the wholeness of women's experience nor does She offer a multiplicity of models for being a woman or a mother. She has been made small, confined to a few of Her attributes, divested of magnitude and power, overlaid with stereotypes of womanhood--as have the women whose lives still mirrors Hers" (*In Her Image* 76).

I rejected the passive qualities and portrayals of Virgin Mary. I needed a strong heroic protectress to defend me when I was a child, not one who was pathetic and weak. I believe that powerful Goddess images will help free women from their culturally assigned roles and contribute to empowering them to rise to their full potential. I believe our inner

Goddesses can lead us to our power. Would the reimaging of the inner Goddess empower women? Carlson argues that women (regardless of the condition of their relationship with their biological mother) can benefit from the positive representation of the Goddess because "the fullness of the Mother is beyond the capacity of one human being to manifest" (102). According to thealogian Carol Christ, the Goddess shows us what has been missing in our culture: positive images of our power, our bodies, our wills, and our mothers. Through these images of the Goddess, we can remember ourselves and so visualize ourselves whole again (286).

Dragon Mother Goddess

I sat, hypnotized, by the black foreboding eyes of the *Dragon Mother Goddess* (see Figure 1), as I was curious about what was hidden behind them. The *Dragon Mother Goddess* was my introduction to acrylic painting and intentional creativity methodology, which was founded by artist and educator Shiloh Sophia McCloud; the practice involves painting with the intention to heal to connect with our inner wisdom. Looking into her eyes, I saw myself reflected. My oldest daughter was born in the Chinese zodiac year of the dragon, which makes me a Dragon Mother also. Two Dragon Mothers looking at each other. It dawned on me that I have reached full circle in my search: The Goddess is my mother, my confirmation, and my strength. In a sense, I have been looking for a second mom ever since I was a young child. My quest for an outer mother has metamorphosed into inner exploration. The Goddess resides inside me and awaited my discovery and acknowledgment.

I felt I was in a trance while painting her and was shocked to see a Dark Goddess emerge. I was puzzled by her dark skin colour, which led me to delve into the wonderfully rich world of the Black Madonna, including a pilgrimage to the Notre-Dame de Bonne Délivrance in Paris. I read Jungian analyst Betty de Shong Meador's, *Uncursing the Dark: Treasures from the Underworld*, in which she explores Inanna's descent and demonstrates how it mirrors women's descent and initiation to the divine feminine: "Within her psyche she carries a wounded child thwarted in her natural development. Nevertheless, this child carries the seeds of female instinctuality that can lead the woman to the Self"

(53). Her skin is dark and rich, a connection to the fertile soil of Mother Earth. This dark Dragon Mother is unlike the Virgin Mary; they are almost complete opposites. The Dragon Mother emitted strength and power—someone I can take in and accept. When I was a child, I wanted and needed a mother who could protect me, and I could see the Dragon Mother playing that role.

After my initial encounter with my Dragon Mother, I continued to paint and turned in paintings in lieu of writing assignments whenever I could for my degree. A year later when I was painting the *Legendary Self* (see Figure 2), I remember looking up from painting the face, only to see my mother's eyes staring straight at me. Five years into therapy, I concluded my relationship with my parents was too toxic, and I decided to step away. Was I upset when I looked up at my painting to see my own mother's eyes staring back? I was surprised, shocked, and furious that my mother had somehow managed to enter my safe creative space. I was upset she had reared her head into my life when I thought I was done with her. Later, a friend commented that that this particular Goddess's eyes also resemble my daughter's.

Was it serendipity that I painted my mother's eyes? In fact, the eyes in the painting are revised versions of my mother's. My Goddess's sclera is white and clear, but my mother's was bloodshot. Or was it a wakeup call from my inner mother wanting to be recognized? Could my artistic endeavour be an outlet for her to communicate with me and to express her love? Is the Goddess my inner mother after all? Could connecting with our inner mothers allow us to free ourselves from patterns adopted from our biological mothers and get us closer to our genuine selves? Would acknowledging and nurturing this inner mother heal wounds inflicted by our outer mother? As Zen Buddhist monk and teacher Thich Nhat Hanh states, "With the practice of meditation, we can still see the cord connecting us to our mother. We can see that our mother is not only outside of us, but inside as well" (18). Even though I can sever ties with my biological mother, I cannot run away from my inner mother: "If I can transform and heal my mother or father inside of me, I will be able to help them outside of me also" (67).

Soon after painting the *Legendary Self,* I painted *The Landscape Within* (see Figure 3). Again, I discovered I had painted my biological mother, masked, as I never got to know her. In the painting, my "little girl" is hiding behind the masked representation of my mother and Medusa. I

had not planned the painting that way. In fact, when I paint, I simply transfer visions, or fragmented images I see, onto the canvas. Looking at the girl hiding behind her masked mother, I recognized my inner child and the plight she was in. When I found her a few years before during a red tent gathering visualization exercise, she was a chalky-looking, shrivelled-up fetus. I cried when I saw her and assured her that I would protect her; but in truth, I was too scared to even look at her, let alone to discover who she was. If your own mother does not want to see you, you start to wonder what may be wrong with you. My inner child stayed hidden for a long time, barely alive, devoid of a self and desires. Seeing her again in this painting, even though partially concealed, was a welcome sight. Her red hair and rosy complexion bring vibrancy and vitality. I notice sadness in her eyes, but she is seen, and she is with Medusa. I have always been fascinated by Medusa's story, an attraction I never understood until recently. Medusa was victimized, penalized, punished, and demonized. She was powerful but misunderstood and led a lonely life. Her gaze does not petrify me; it reassures me. I feel seen by her; she is my protectress, my mother. With her by my side, perhaps I will finally be able to step into this ancient power and make it my own.

My head was spinning at that point, not entirely sure what was being revealed to me through my paintings. Reluctantly, I picked up Carlson's book *In Her Image: The Unhealed Daughter's Search for Her Mother*, even though the title really turned me off. There was no way I was the unhealed daughter searching for her mother; surely I had paid my dues, having spent years hashing everything out with my therapist. As it turned out, there was no escaping. What was I to do but to dive in headfirst?

Carlson's book explores the very human problems of mothers and daughters and their deeper psychic roots. Not only does the book examine the strengths and problems of the mother-daughter relationship, but it also set them within a transpersonal context as part of an individual and collective inner journey (*In Her Image* xii). Carlson's book acted as a guide for me, riddled with messages and confirmations. When I discovered my mother's eyes staring back at me in my *Legendary Self* painting, I was unsure what to do with the resentment that emerged. The flashback to my mother's bloodshot eyes brought heartache and a relationship I deemed futile.

Yet the eyes I painted do not carry the unrelenting pain my mother's carried. These eyes were subconsciously designed to offer support and

assurance; they restore and revive my inner child. They are looking directly at my inner child. She has her mother's attention now and can move out of her hiding place—a place she created to survive her childhood in which she subsequently became stuck because she felt unseen and inadequate. It is only when your inner child feels seen and loved that she can grow and for us to come to our power and to live the life we are meant to lead.

I concluded it was my inner mother who wanted to connect with me through my paintings. Unlike my outer mother, I can affect my relationship with my inner mother. It was both liberating and healing to realize that my inner mother is available to me and to understand that this inner mother is the Goddess within. Carlson states: The inner mother may function like an unconscious legacy, needing and wanting to be made conscious and helped, whereas our outer mothers may not want this at all or be capable of it....We must be willing to *suffer* our mothers within us, to see to the roots of their behavior within us, and to forgive and transform it in ourselves. (57)

Who is this inner mother but a part of myself who needed to accept, embrace, witness, and recognize myself? I was so busy trying to become who my parents wanted me to be, and then rebelling to be the exact opposite, that I could no longer hear myself, nor did I know how. While my inner child was being squished into my parent's mould of who their child should be, my growing self began believing and adopting my parents' attitude of my own unworthiness; my inner child had nowhere to turn. With the discovery of my inner mother, I realized I held the answers to the dull pain that resided within; I could stop putting my life on hold and stop looking outwards for the mothering figures I needed.

In *Life's Daughter/Death's Bride*, Carlson describes the bond between Kore and Demeter, the mother who would not give up her child and who stood up to Zeus and the patriarchal rule. It is a bond that most women aspire to have with their own mother:

Many of us did not experience this aspect of the archetype coming through our personal mothers; it is left to the Goddess or to other human beings (or sometimes, even animals) to convey and mediate this sense of being passionately valued for who we are, of being individually irreplaceable. Ultimately, the exper- ience of this kind of love from another can be internalized and become the ground-note not only of a healthy self-love but of a

passionate drive to individuate—to actualize as fully as possible one's own, authentic, individual self. (70)

Carlson sums up my own journey of internalizing the Goddess's love: healing the wounds accumulated from the patriarchal culture and a biological mother steeped in that culture and finally finding myself in order to fully live up to my own potential.

Reclaiming Mother Mary: Her Sacred Face

Before the Art as a Sacred Practice class, I had never dreamed of using colour in my artwork nor was I able to access it. I took graphite pencil drawing classes in my preteen years, and my younger sister took acrylic painting classes. Perhaps, I never ventured out of that pigeonhole because I thought that was where I belonged. Or maybe it was related to the fact that I had focused so much on form in ceramics that when the time came to glaze the piece, it was always a struggle to add colour to the established form. Fortuitously, I believe the protective mechanisms I built in my childhood were not aware of this gateway to my inner self, so it remained unguarded.

This may explain how I can now tap into a part of myself to which I previously had no access to, although in truth, I had sculpted my share of Goddess statues in my early twenties. At the time, I sculpted female faces without recognizing the divine connection. I saw images that wanted to take form without noticing or receiving the messages that were behind those transmissions. I remember one specific sculpture with a distorted face pierced by a horn, with blood dripping into a black hole. My sculptures held my pain, symbolic of the agonizing and unfulfilling relationship I had with my outer mother. I focused on the form and texture; the colour came as a troubled afterthought. As bell hooks writes, "Representation is a crucial location of struggle for any exploited and oppressed people asserting subjectivity and decolonization of the mind" (qtd. in Leavy 219). My ability to create beautiful, powerful images of the divine within me, of my inner mother, has liberated me from bondage. My mother signed me up for a pencil drawing class in my childhood, and I stuck with that way of seeing the world in my artwork for almost my entire life. In contrast, my inner mother led me to see the world of vibrant colours. This shift affects not only my artwork but also my whole perception of the world. Perhaps now, I will be able to see the

world with my own eyes and not with the restricted version presented to me as a child.

My fascination with creating faces started in my twenties and continues on into my goddess paintings. The faces I make are distinct and different. Human faces are unique like our fingerprints; no two are the same even between identical twins. In fact, as Marcina Cooper-White cites from a recent study, "Evolution has favored humans with distinctive facial features because it is beneficial for people to be able to recognize each other, and be recognizable" (1). Evolution selects individuals with easily recognizable features, which pushes us towards having broadly different faces. Yet I was forced into a mould my parents created so I would appear acceptable to society, but it was a persona that did not belong to me. My desire to create faces may be my inner child's way of demonstrating the futility of that kind of thinking. It may be my inner child's way of manifesting the kind of mothering she needed—one that appreciates the beauty in each being's individuality and in her own authentic uniqueness.

In the process of painting the goddess into existence, I imbue her with qualities of the feminine that I craved growing up. Looking directly into her eyes, knowing that I had her full attention, filled my heart with the love, healing, and acceptance. When you're told by your mother from an early age that you are not good enough, you begin to believe that something bad resides within you. You box yourself up; you keep the bad away, adopt, and assimilate other people's value over your own. In so doing, you forget who you are. I paint faces of the goddess in order to find my true self, my voice, and my face—a face that can see and be seen by her mother.

I, thus, came to realize that my resistance towards the Virgin Mary had something to do with my relationship with my mother. I decided it was time for me to face Mary and try to understand my relationship with her and why she kept popping up in my life. I went to my canvas and paints and started my dialogue with Mary (see Figure 4). The strong emotional contempt I have for the Virgin Mary was a good hiding place for me. I was afraid to unearth whatever it was that I had discarded. I had directed a lot of my resentment for my own mother onto the Virgin Mary. I felt abandoned by both, and I held a lot of animosity towards them. While writing a reflection paper about my painting *Mary* for class, I wrote, "I believe I created a glamorous Goddess." Then it hit me: My

biological mother has always been described as glamorous. I fashioned *Mary* after my mother. My inner child yearns for her mother, and in my painting, I gave myself the mother I wanted, all to myself. Mother is looking at me and seeing who I am. I went through countless therapy sessions refusing to acknowledge the fact that I want my mother's love and for her to see and acknowledge who I am. I even remember saying to my therapist that it is pointless to want something I cannot have and that it would only lead to more heartbreaks. When I finally stopped fighting the Virgin Mary, it brought healing, understanding, and a means to care for and nurture my inner child. I have been fashioning the mother I wanted, canvas after canvas, so my inner child can finally be made whole again. In essence, I have remothered myself. Painting in colour represents the ability to live life fully instead of the restricted black-and-white subset to which my inner child had grown accustomed. The world of the many shades of gray was a safe one to live in, but this world of colour offers opportunities to know myself that were previously unavailable. My panacea lies in seeing and believing that I am the Goddess in all her beauty and power and that I have the ability within to live my life passionately and fearlessly.

Figures: Appendix

Figure 1. *The Dragon Mother Goddess*

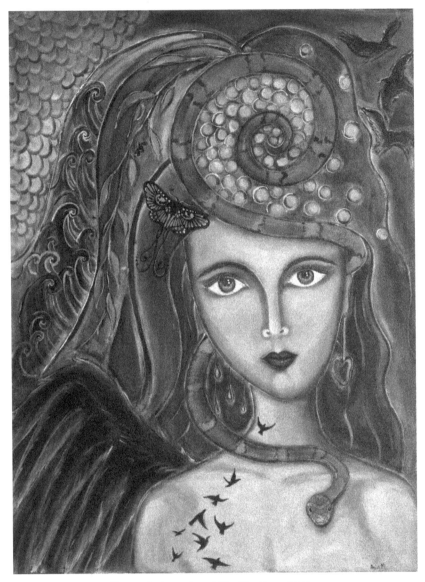

Figure 2. *Legendary Self—The Great Mother*

Figure 3. *The Landscape Within*

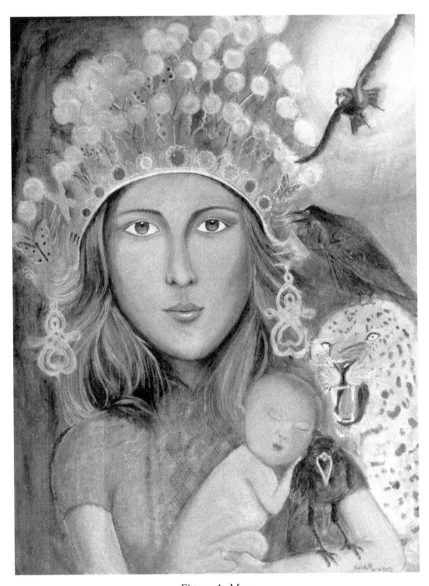

Figure 4. *Mary*

Works Cited

Carlson, Kathie. *In Her Image: The Unhealed Daughter's Search for her Mother.* Shambhala Publications, 1989.

Carlson, Kathie. *Life's Daughter/Death's Bride: Inner Transformations through the Goddess Demeter/Persephone.* Shambhala Publications, 1997.

Christ, Carol, and Judith Plascow. *Womanspirit Rising.* Harper & Row, 1979.

Cooper-White, Marcina. "Here's the Remarkably Simple Reason Your Face Is Unique." *The Huffington Post,* 18 Sept. 2014, www.huffington post.com/2014/09/18/humanfaces unique_n_5837910.html. Accessed 23 Nov. 2020.

Hanh, Thich Nhat. *Reconciliation: Healing the Inner Child.* Parallax Press, 2010.

Leavy, Patricia. *Method Meets Art: Arts-based Research Practice.* The Guilford Press, 2009.

Leggo, Carl. "Astonishing Silence: Knowing in Poetry." *Handbook of the Arts in Qualitative Social Science Research,* edited by J. Gary Knowles and Ardra L. Cole, Sage Press, 2008, pp. 165-74.

Meador, Betty. *Uncursing the Dark: Treasures from the Underworld.* Chiron Publications, 1994.

Wood, James. *How Fiction Works.* Farrar, 2008.

Chapter Four

Minks

Elizabeth Cunningham

On a winter morning
my daughter goes out to feed her rabbit
wearing my grandmother's mink coat and stole
over my mother's blue-quilted bathrobe.
Coming back down the drive
she glides on the ice as much as she can.
The dog jumps at her, excited by the antique furs
the stole made of whole animals.
My daughter defends the minks
and shoos the dogs away.

Inside, she comes to show me her outfit.
We sit and talk about the coat
how old it is. I remember playing
with the stole when I was a child,
how each mink's mouth was a clasp
biting the next one's leg or tail.
We need to say a prayer for the minks,
my daughter says. Without embarrassment
this almost teenaged child
places her hands together at her heart.

"Forgive our ancestors for killing you
for taking your lives
for the sake of a coat. Forgive us
for wearing your fur

as we honour our ancestors.
We will protect your children
and your grandchildren.
When we wear this coat
we will give thanks to you for warmth."

I look in awe at this youngest
of my mother's line in her ancestral robes
how her prayer rose so surely
from her nature to embrace
foremothers and minks at once.

Chapter Five

"Call Unto Thy Soul": A Reflexive Autoethnography of a Pagan, Priestess, Goddess-Worshipper, and Mother

Alys Einion

> "Call Unto Thy Soul.
> Arise, and Come Unto Me,
> for I am the soul of nature
> that gives life to the Universe."
> —Farrar 193

In my life, I have been a priestess—High Priestess of a Welsh pagan tradition—led covens, and have experienced the Goddess in her many guises as I negotiated my path through womanhood, maternal loss, and motherhood. I have become a nurse, midwife, healer, and author. This chapter analyses my journals covering thirty-three years as a goddess-worshipping woman and explores the interaction and intersubjectivity of paganism and motherhood, goddess worship, feminism, and midwifery. Utilising the methodology of reflexive autoethnography allows me to incorporate the personal and political, as well as the critical and theoretical, into a living, breathing exposition of the centrality of Goddess as the source of meaning, strength, and understanding within a spiritually deficient wider world, which continues to negate women's empowerment and magnificence.

Autoethnography is a mode of enquiry that derives from a range of disciplines; it allows the author to engage in "critique and resistance," consisting of "a self-narrative that critiques the situatedness of self in social contexts" (Spry 706). A key dimension of understanding self-narrative is the process of self-construction in and through narrative, both narrative construction and narrative consumption. As Jerome Bruner shows, these narratives, told and retold to ourselves about ourselves, define who we become.

Autoethnography argues both for the distinctiveness of my personal experience—as evidenced from an analysis of my journals as they were written with reference to the context in which they were written—and for the primacy of the role of the reader in the dialogic nature of this analysis. This is written for both myself and for the reader. This is also written for the unseen reader, the omnipotence of that which we call Goddess—whether that be a projection of my personality, my higher self, or a higher power of some kind.

My approach differs from traditional ethnographic and even autoethnographic approaches (Mcilveen), as I incorporate knowledge of life writing and, in particular, the narrative construction of self. This reflexive autoethnography is both a personal and critical account; it acknowledges the limitations and the essential value of social signifiers of my self as defined by descriptive norms. I explore the nature of a deeply personal odyssey with the Goddess and use as the building blocks the many years of my diaries, which speak to my experiences. I explain the relationship between myself, the Goddess, my life work as a midwife and teacher, and my experiences of motherhood, arguing that the Goddess is fundamental to every aspect of how I view myself as a woman.

In the following text, names have been changed except for a few exceptions to maintain anonymity.

*

As a process of reflexivity, I acknowledge the limitations of this personal analysis in relation to key signifiers of my life experience.

White. I was born to white parents. A distant ancestor is Maori, and that connection has had a degree of significance for me throughout my life, but I grew up as a white child, and I have all the privilege of a white woman. I can only hope that readers from all ethnic groups and backgrounds can find some resonance with my feelings, experiences, and findings.

Ciswoman. I am proud of my essential femaleness. By presenting this account, I have no desire to exclude anyone who does not identify as a ciswoman. I honour and respect all self-identities in relation to gender or any other characteristics. As a feminist, I believe in equality for all genders and that gender is not binary. My feminism does not exclude any gender or identity.

Age. I was born in 1970. I grew up in a time period that was defined by certain social norms and that still carried the weight of recovery from WWII; my parents were born during the war and knew its deprivations. I missed the sixties and was too young for Greenham, but I was part of the protests against Section 28 and the Poll Tax, and I marched at London Gay Pride marches in the 1990s.

Lesbian. My sexuality has been one of the defining features of my life, and it was formed initially in a culture of shame and secrecy and later through association with strongly defined lesbian groups and contexts. However, I would expand that definition to include pansexuality, as the dogmatic ways in which some lesbian groups define sexuality do not sit well with my personal feelings or fluidity.

Context. I am a Welsh woman. I grew up in the South Wales valleys, the coalfields. I grew up in poverty (which was, at times, severe) in a classist community in which my very life chances and choices were limited by social expectations. I grew up in local authority housing, condemned to the underclass because of my address. I was rejected by my peers on the housing estate for being too brainy and by my intellectual peers and schoolteachers for being too poor. This struggle with class prejudice and privilege has been another defining feature of my motherhood journey as a pagan. I spent my life looking for a place to 'fit in.'

Body size. I have, from a young age, been classified as overweight, or as an adult, obese, both of which terms I utterly reject. The body mass index is a heteropatriarchal medical and social construct of optimal body size, with no true scientific basis, and it has affected my experience of the world in profound and powerful ways. It impacts the way people judge, evaluate, and respond to me. Increasingly, it threatens to limit my access to vital services. And it has affected my mothering journey and identity as a woman and a pagan.

*

At age thirteen, on the cusp of womanhood, I was all fire and energy, desire and uncertainty, longing for answers to the deep and burning questions of self and world. Consumed with a gnawing hunger for meaning and connection, emerging from the chrysalis of a childhood of hypersensitivity and social isolation, I had tried on and rejected the misogynistic cloak of Christianity and found myself seeking truth and knowledge of self in a world where nature was my church. A chance encounter directed me to a certain book in the local library, and there, standing on the faded brown carpet tiles amongst the towering metal-edged shelves, I experienced utter transformation as I read the words of Doreen Valiente's *The Charge of the Goddess,* as published in *What Witches Do* (Farrar). I knew then where my soul lived, and She, the Goddess, archetypal in all Her aspects, claimed and possessed me from that moment on. When asked if I am religious, I always state that I have a deep and abiding faith and, similar to other feminists, view religion as a broad term, including "institutional and non-institutional, codified and self-fashioned ... manifestations of belief, practice, embodiment" (Aune 34). However, for me as for many, the association of religion with established institutions and major belief systems (Aune), most of which are patriarchal, is problematic, and I tend to avoid the term.

The centrality of my faith in no way offsets or is offset by the core critical and questioning nature of my active and inquiring mind. The first feature of my life that can be identified from the diary entries is the way that I have, from the beginning, equated my faith with a hunger and thirst for knowledge; 50 per cent of my consciousness is a true believer in "magick" and all that can be accomplished via the application of a trained mind and a strong will, and 50 cent of my consciousness is a skeptic, questioning the validity of everything. Thus, like many other pagans and goddess worshippers, as Linda Jencson so ably puts it, "The concepts of the belief system are first contacted on the library shelf" (4). In fact, for a summary of neopagan beliefs and their connection with anthropological work, and brief but highly accurate summary of the evolution of modern pagan practice, Jencson's article is invaluable. Reading it now, at forty-six years of age, having been a practising pagan for thirty-three years, it makes perfect sense because it is paganism as I know it, if in a rather simplistic form.

The emergent understanding from my reflexive autoethnography of

my life as a pagan, mother, midwife, and lesbian is that occupying the centrality of my identity, an identity constructed and maintained by my self-narratives, is that of woman—female bodied and female spirit—and that all other aspects of my life and self emerge from that core femaleness. As Stewart Farrar puts it, "All thy seeking and yearning shall avail thee not unless thou knowest the mystery—that if that which thou seekest though findest not within thee, thou wilt never find it without thee" (Farrar 194).

I knew I was a feminist at the same time that I knew I was a witch. The Goddess—that unnameable feeling of "something" that I associate with connection beyond my physical and psychic self—became manifest the moment I read *The Charge of the Goddess* and understood that the divine feminine not only existed but was unavoidably and palpably associated with my deepest sense of self: my femaleness and my sexuality.

Significantly, I was standing in a library.

I was thirteen years old. This is also a significant fact.

Thirteen was the age when everything changed for me. My child body had morphed into full-bloom femininity; menses began, and in a corner of a library I underwent an epiphany. I had always known that there was more to me than the purely secular and rational and more to life than the limitations imposed by so-called reality. I had tried Christianity on for size. I spent two years struggling with a deep sense of the spiritual and found little within the Anglican Church that made sense to me, once I understood the deeply patriarchal and predominantly misogynistic nature of many of the teachings of the Bible. Yet in my deep sense of spirit, of other nature, I was aware of some wider force, for the lack of a better term, some higher power—something both greater than me and inherently located within my self.

But I could not escape the feeling that everything about myself was defined by my gender. It is evident from my early writings that I struggled with the expectations of being a girl—that is, I would have crushes on boys and accept their advances. Neitz suggests that "Putting women at the centre of analysis ... produced ... a vision of the world as gendered" (370). This is how my feminism came into being. It began at that point when I put Goddess at the centre of my activities and thought processes. It was the first point at which I was able to fully construct a sense-making frame about what I had known, implicitly, my whole life: I live in a world experienced differently by men and women (Neitz 370), and the world

and our experiences of it have been defined by men for women. And it made no sense that men should run the world when everyone is born of a woman. Everyone. Without women, we do not exist. I definitely have issues with authority and finding out that my very sense of self was being limited and even oppressed by patriarchy both outraged and upset me.

Thirteen was also the age when I first fully recognized my attraction to my own gender. This was another step outside the boundaries of normality and into the shaded realms of sexuality, which remained, at that time, dangerously mysterious.

The social and cultural dominance of heteropatriarchy seemed to affect every aspect of my being. Yet here was Wicca, Goddess-centred, offering me a religion in which women possess and are afforded the power and authority they deserve.

In this chapter, I quote Mary Jo Neitz as a means of defining terms: "I use the words Wicca and Witchcraft interchangeably. Both words describe a set of beliefs and practices embraced by networks of individuals, loosely organised, without a hierarchical structure" (373). Although I would argue somewhat with the last point, because in my experience most neopagan groups are very hierarchical, this definition serves well to encompass what witchcraft has meant to me.

The first book that I read on witchcraft was *What Witches Do*, by Stewart Farrar. Farrar was a journalist and writer, who investigated the resurgence of witchcraft in the 1960s and joined the coven led by the notorious and complex Alex Sanders. Sanders claimed, like Gardner, to have derived his tradition from an ancient source, but in this case, he proposed to have inherited it from his grandmother. It was nothing more than a direct copy of Gardnerian Wicca with a few change and additions. But the book, with its shocking black-and-white pictures of naked or scantily clad witches in various ritual poses, told me everything I had wanted to know: Women were celebrated and honoured. There was a deep spirituality that I had skirted the edges of, and here was someone putting it into words. Here are some extracts from my diary reflecting on that experience.

The stacks are old, wooden, reaching high above me. To the left is a window, grey with rain and condensation, dirt and mildew in the ridges of the frame which extends to near the floor. The carpet tiles are charcoal, rough and uncompromising. Behind me are row upon row of shelves; beyond them the two doors and the D shaped issue desk. This

section back wall contains books on religion, theology, and.... The occult. I was sent here. Matthew told me to take this book out. Matthew, my new friend, spooky Matthew as everyone calls him.

Standing there, my thirteen-year-old self, squeezed into too-tight jeans and a pink jumper, devours the words and finally, at last, reads the charge of the Goddess.

What is Goddess?

She is all Woman. She is the ancient generative force of nature, the power behind everything. She is the earth that bears us and gives life, the growing earth and the cold earth and the green of spring and the moon at midnight. She is Maiden, Mother, Crone. She is every stage and every aspect of Woman. She is me.

I am eighteen years old and standing with Matthew, my pagan friend, in a bookshop in Cardiff, in front of the Occult section (do you see a theme here?). We are approached by a man in black, with a pentagram on his chest hung from a silver chain. He moves with import, self-importance. He exudes an aura of power and mystery.

This was my first encounter with a witch other than Matthew. Rolf was an initiate of Alex Sanders and ran an Alexandrian coven in the city closest to my home. Need I say more? Those who know will understand. Those who do not will not. We talked. He offered initiation. I accepted, although Matthew didn't. And so, within a few weeks, I stood naked and blindfold in a room full of strangers and trusted the Goddess that this was the right path. I had so wanted to be part of a tradition and to learn the secrets and the mysteries. That hunger for knowing drove me; it was tantalized and refined by the secrecy of the supposed arcane teachings of the coven, requiring me to submit, and to join the coven to learn. Another life motif of mine is that dreadful, unending curiosity and the consequences of giving in to it.

There were three men in the coven and three women. The nature of this coven was typical of many at the time; it followed the rituals and proscriptions laid down as teaching, which really involved very little practical instruction. But it was an opening into this world, and one I felt I had been waiting for. My diary entries are a combination of nineteen-year-old naiveté, snatches of spiritual insight, and the burgeoning awareness of both the opportunities and limitations of the context. They were people. They were often more interested in going to

the pub and getting into each other's beds than in spiritual awakening, quest, or learning. There were snatches of insight, drifting threads of knowledge, of power, that lightly kissed the edges of our Circle. But it was not enough.

My soul was left hungry, and my journal entries encompass a theme of questioning. The narrative construction of self at this point can be seen in an almost aggressive assertion of self, which pushes against the restrictive context of my family, particularly my parents. The attraction of this coven is partly due to the fact that it is taboo and therefore my own private/secret world in which I get to act and be treated as an adult for probably the first time in my life. But the spiritual side is also sharply present. Through ritual I find a connection with the greater something I have always felt. It just seems that this is no different in this group setting than it was when I was carrying out rituals in whispers in my tiny bedroom, cross-legged on a tiny circular rug in front of the light of a single candle. I had come looking for something yet had not found it. I was embarked on my own process of self-sacralization (Hautman and Aupers), which embodied the very words which had first inspired me: "If that which thou seekest, thou findest not within thee" (Farrar 194).

A brief sexual relationship with one of the men in the coven complicates this time yet also simplifies some aspects of my journey to the Goddess. She connected me to my body and, for the first time, to a lack of shame in my body and in my sexuality. Although childhood conditioning had left me pitifully grateful for male attention and affection, I felt that losing my virginity was a powerful personal act and one that liberated me from the burden of the significance of losing it. It was easy, despite my lesbianism, to connect with these men because we shared a common energetic bond. For me, the pagan man was a face of the God, and in that sense, the sex was both physical and somehow spiritually sanctioned. In the context of Alexandrian Wicca—with its obsession with male-female dyadic connection and its argument that energy only truly flows between the two poles—sex with men was a logical and generally pleasant aspect of the experience. As Valiente states, "For two are the mystical pillars, that stand at the gate of the shrine. And two are the powers of nature, the forms and the forces divine (173).

Although I was aware then, and remain acutely conscious now, that all of these forms are in fact symbolic constructs imposed to engage in sense making about a spiritual set of experiences, as with all religion and

faith, there was a comfort in expressing something that I had long been reading about and longing. It made me feel powerful. It made all the parts of me that were rejected by my peers—my sensitivity, both psychic and emotional; my connection with nature; my powerful emotions; my graceful, dancer body, weighed by apparently excessive flesh; and even my intellect—all fall into place. In fact, it allowed me to celebrate these parts of myself for the very first time.

My connection with the Alexandrian coven spanned nine months. And then, at an open ritual for pagans in our locality, on a dark and windswept night, I met Merlin, first and last scion of the Gwyddon and the man who would change my life. We met in a car park near to Nash point, part of an ancient, prehistoric coastline, and scrambled down a precipitous path to a narrow cleft between the cliffs, with the sea roaring and crashing as we built our fire and danced and sang and drank wine and firewalked. Afterwards, I endured a journey squashed into a car with too many others in order to arrive at a flat on the first floor with huge bay windows. We sat on cushions while Merlin read my palm and looked deep into my eyes, and I felt Her overshadowing me, filling me. I knew that we had made a connection that was beyond physical. I had never before felt so fully known and seen.

He was a gay man. I was a lesbian. Three months later, we met again, became lovers, and married. I became his High Priestess as he brought me into the Gwyddon, his self-styled tradition rooted in a few fragments of inherited lore and augmented greatly by his own knowledge, learning, and creativity.

The self-story here follows a truly typical narrative arc and is perhaps entirely predictable. We both felt propelled into each other's arms and that this was fate. For me, the Goddess was speaking through Merlin and through the things that followed. Unlike other pagans I had met, this man was truly powerful. I now know that he saw my own power and was attracted to it; he saw the confluence of intellect, sensitivity and connection with that great flow of universal energy and wanted it for himself. But I also believe that he truly loved me. The omnipotent and omniscient Narrator was moving us along a particular path towards a particular end. It was through Gwyddon that I deepened my knowledge of the Goddess, of ancient traditions of witchcraft, herbalism, shamanism and divination. In the time with Merlin, I read widely and deeply and engaged in studying his craft and performing rituals over and over again

until they became second nature. I led covens, taught others, and experienced the greatest challenge of faith I would ever experience in my life.

At twenty years old, I became pregnant. It was not planned, but it was, when it happened, fully celebrated and welcomed. In this incipient motherhood, I felt, lay every expression of my connection with the Goddess. She is Maiden, Mother, Crone, and I felt that it was fate—becoming a mother was my destiny. I had been an atypical child and adolescent and had never wanted children or dreamed of marriage. The All-Mother was made manifest. It was to be the greatest spiritual journey I could possibly imagine. I trusted my body and felt alienated from local midwives who treated me badly. When I went into labour, I used breathing and herbs to cope with the experience and only submitted to medical intervention when they insisted my labour needed to be accelerated. I accepted Pethidine, which was a horrible experience, as I reacted badly to the drug and began hallucinating.

And just at the point of pushing, when I felt I was beyond saving, I called on the Goddess, the Great Mother, in pain and fear, as I was unable to connect with my body because the drugs and the lights and the stress had cut me off from myself. I called to Her. And She came. She came in the form of a midwife, Francesca, a thin woman whose eyes held mine, who offered me her hip, whose gaze caught my soul and held it firm, as she said "Put your foot on my hip and push!" And I did.

I pushed and I roared. And in that moment, I knew, with the greatest certainty I have ever possessed in my life, that that was what I was meant to be: a midwife. This true witch is a healer and a wise woman, who carries and holds the souls of women through childbirth; she acts as their guardian and their guide and creates that sacred space for them to transition through from woman to mother. Even as my firstborn son's body finally slid into the world, as I felt the cruel bite of scissors as the doctor cut me, I knew. It was a clarity I have rarely approached since.

Two days later, my beautiful boy, my firstborn, died. No one knew why. They called it SIDS, but he died in a hospital, in a special care baby unit, with doctors and nurses battling to save his life.

Gone.

My son, my precious, was gone, replaced with great gaping hole of emptiness and loss and the vacuum of what was and what could have been, what should have been. I was a mother with no child.

It was the darkest time my life and the most spiritual because through all of it, I felt Her presence and that of my spiritual brothers and sisters. A friend put a call out immediately to every pagan he could contact, asking them to support us, magickally, because Merlin and I were in great darkness, struggling to find any light. Through those first, terrible weeks, it was as if invisible hands were holding me up. People I had never known or met, pagans all, sent cards and messages. I felt surrounded by energy and love. It was an unspeakably difficult time, bitter and black with shards of piercing darkness, blades of obsidian cutting me at every turn. To this day, I know it was the Goddess that got me through. I chose the hard path. I chose to accept, to live, and to listen to the lessons I was being taught. One loving stranger sent a card to me, with a beautiful print, and the following verse:

Sorry I had to go,

So very quickly

But I had to come,

And return

It was necessary, for me!

Be happy for me

Thank you for loving me.

There are no words to describe life after the death of your first child. You are a mother with no child. All the bright promise of the future is gone, and the dreams and plans have been erased and rubbed out. There is the sheer bloody weariness of all that pain as well as the weight of grief that you must somehow shoulder and carry—knowing that you will carry it every day for the rest of your life.

It was at this point that I constructed a new story. I rehearsed and reviewed it and told it over and over. My son had come to me to show me my life path, my purpose. I was to serve the Goddess as a midwife, a true witch, a healer. Each step on my journey was oriented towards this vision. She walked beside me, beautiful and terrible, wearing her Fourth Face, veiled and unknowable.

Merlin and I separated a year later; he moved in with his boyfriend, and I began my first long-term relationship with a woman. Sandy had been a member of our coven. She knew me first as priestess, and our common language was that of the Goddess. She knew me as a mother

without a child. It was still so raw that I could not help but talk about it. The world was peopled with mothers and children, and I looked on, outsider and adrift. But Sandy was aware of my goal. A year later I began nurse training. I spent three years learning how the body works, how illness works, and how medicine treats illness as well as how medicine excludes women. It was an exercise in endurance, particularly in the ability to learn to fit in enough to be allowed to join the ranks of the nursing profession.

At twenty-three, I was shopping in a small town in North Wales and happened to call into an alternative shop to peruse the incense, silk scarves, and windchimes. I had no money, being a student nurse and living on a bursary, and at that point, all I had was what was in the bank—the exact amount of my rent for the following week. In the glass display case that served as the shop's counter, there was a silver Goddess pendant, based on the Venus of Lespugue. You can find these anywhere nowadays, but back then, I had never seen anything like it. It was solid silver, about an inch and a third long, thick and heavy. She called to me. I was compelled, by the power of that image, and the sense that there was a true worship of She, the All-Mother, built into the shaping of this object. The assistant told me that she was made by an artist, a one-off project, an experiment. Solid silver. Sold to pay her rent. And the price? Exactly the amount I had in the bank. I prayed to the Goddess, saying *I know I am meant to buy this piece of You, so please, find me the means to pay my rent next week.* I nestled her around my neck on a thong and felt as if something in my life just clicked into place.

Two days later, I was offered some work that would cover my rent and a little extra. The pendant is around my neck still. I never take it off. When I was thirty-three and working as a midwife in a busy delivery ward, a senior colleague spotted her and told me to take her off, as it was against uniform policy. "Sack me," I said, walking away.

Countless women in labour have seen her, touched, her, and rubbed her belly for luck. She is in every photograph of me taken between then and now. Even when I feel as far from the Goddess as one can be, when the world beats me down and life seems too hard, when lovers are cruel and when despots foment fear and unrest in the wider world, She is there, anchoring me back to my true self.

I moved to London to train as a midwife. This manifestation of self was partly spiritual, partly personal, and partly intellectual—a means

to become something that reached beyond all that I was at that point. However, the process of becoming a midwife meant an ongoing battle with heteropatriarchal norms and cultural constructs, such that the spiritual yearning that aligned me with midwifery was not manifested in the mainstream healthcare culture I encountered. As Clarissa Pinkola Estes writes, "A woman's issues of soul cannot be treated by carving her into a more acceptable form as defined by an unconscious culture, no can she be bent into a more intellectually acceptable shape by those who claim to be the sole bearers of consciousness" (4). Yet that was what was attempted. The culture of nursing and midwifery is one in which midwives must constantly struggle against the oppression of themselves and the women they serve. My journals evidence this—both my joy at the deep and complex knowledge and the ability to work with women and my anger and frustration at the low status of midwifery in the wider world (not to mention its arrant heteronormativity).

At age twenty-seven, I qualified as a midwife. Sandy and I separated six months previously, and just before qualification, I became pregnant with my second child. Life changes in a heartbeat, from one moment to the next; chance encounter leads to connection, which leads to disconnection and the most unexpected outcome. A single pregnant woman, I was made homeless by my employer. I could not return to work after the birth, as I could not afford the cost of childcare. It was this experience, of the transition to motherhood as a time when I had to essentially rebuild my life from scratch, that consolidated my understanding of self and Goddess, midwife and mother, as well as priestess and witch. All my life it seemed I had walked a path meandering between personal and professional, obligations to fit in and the strong sense of difference—lesbian, feminist, and witch—which made it difficult to connect with other women who did not feel the overpowering sense of injustice I did when contemplating the limitations placed on me by almost all social institutions.

With a little help and a lot of love from lovers, and some good friends, I carved a path through life as mother, midwife, and witch. I ran covens, cooked nutritious food for my child, studied part time, and worked part time and then full time. I sometimes had two or even three jobs at a time, working around the limitations of social structures that continue to make life very difficult for working mothers. Rejected by my family, with no real social support, I rebuilt my life, and my mothering journey was my

motivation to succeed. I would create safety, security, and happiness for myself and for my son, despite the constant rejections of local society and the complete withdrawal of the people who should have been his extended family. I could get no childcare because I was a lesbian. My son was bullied from the moment he went to primary school because I was a lesbian. He had little contact with grandparents and other family, because I was a lesbian and a pagan. Yet, somehow, we survived and thrived.

In 2005, I became a midwifery lecturer, and at last, there was the scope to realize my goal of not just resisting but challenging and changing the very institutions I continued to fight with daily. I learned how to subversively pass on my knowledge and insights to every woman I taught. And this is what I teach them.

There is a great power in being a woman. I had not realized until that point just how powerful women are. Our bodies are designed, from the moment of conception, to bear children and to feed and nurture them, but that is not all that we are. It is not every woman's or birthing person's choice or desire. But studying midwifery within a medicalized model did nothing to deter me from sharing that deeper, spiritual understanding of pregnancy, birth, and motherhood with students and expectant parents. Every aspect of the physiology only reinforces my psychic and spiritual sense that women are, in fact, far more powerful than men, more powerful than men will ever be, and that the whole reason patriarchy has been oppressing us all of these years is because they fear that power and are jealous of it. The almost limitless power of womanhood sets her apart and above that of the male. Yet a huge history and current social construction of women as evil, of their sexuality as dark and dangerous, has subverted this vast and great power and minimized or even removed it. Why else would so many cultures be obsessed with female genital mutilation, with controlling women through the mutilation and removal of their organs of sexual pleasure and making sexual intercourse and childbearing painful and dangerous?

Every woman is a Goddess, and at the point of orgasm and the point of birth, and at other times and in other ways, she is transcendent in her power, connecting to the Divine without effort. This is my experience and that of many other women. Yet women's ability to connect on this deep, natural level is interrupted by a medicalized and highly patriarchal, often misogynistic system of care that alienates them from their bodies,

their essential power, and the wonder of the physiology of pregnancy and birth. Just as patriarchal religions have done for centuries, medicine has alienated women from themselves and their power, and society alienates them from a true understanding of their own nature. As Monica Sjoo and Barbara Mor say: "Throughout the world today virtually all religious, cultural, economic and political institutions stand, where they were built centuries ago, on the solid foundation of an erroneous concept. A concept that assumes the psychic passivity, the creative inferiority, and the sexual secondariness of women" (5).

A report, published in 2015, demonstrates how the hormonal physiology of birth enables women to bear their children safely and comfortably, but modern maternity care practices interfere with the natural processes of childbearing (Buckley). Yet we continue to restrict women's choices in childbearing by constructing a false narrative of birth as being so inherently risky that women need doctors to tell them when they are in labour and when they should be having their babies and how long their labour should be. It is all a form of oppression and control by a patriarchal medical system, which creates more risks than any it avoids and which absolutely negates the powerful and spiritual nature of birth for each woman. It oppresses midwives as much as childbearing women, as it makes them scapegoats when anything goes wrong and leaves them fearful of exercising their professional role in supporting women's autonomy and choice. Instead, many midwives become instruments of the very system they should be protecting women from. Coming to this knowledge and disseminating it reinforced my connection with the Goddess. I found Her again and again in the work I did (and still do) daily.

In 2012, I completed a PhD in creative writing, in which I interrogated women's life writing, narratives, and other aspects of story, which enabled me to fully understand the nature of story and how it connects us to our selves and to the wider world. It was through this journey I realized that the Goddess, and my identity as Her instrument, was a story I had been telling myself for over three decades. A story which repeatedly overturns the stories others tell me, about me. For every voice that has said, "You will never," the Goddess compels me to say, "Watch me."

Writing my own books, particularly my novels *Inshallah* and *Ash*, brought me to an understanding of women's ability to integrate faith and

belief into self, and helped me to be confident in standing up for the rights of all women and challenging the forms, forces, and structures that continue to oppress us. The responses of readers confirm my choices were right. Despite writing unconventional characters who are not attractive or easy to relate to and making explicit some deeply personal abuses visited upon women by men and by society, my work resonates with my fellow woman.

And so I come to 2020, to the now, to the realization that if the Goddess truly is a story I tell myself to make sense of my soul connection with this earth, with other people, and with the roles I fulfill and the peace and fulfillment I seek daily, then it is a story I want to share. I complete this chapter in my office at home, with goddess prints on the wall, goddess figurines on the shelves on all sides of me, goddess books stacked around me, and my silver goddess still around my neck. I am no longer apologetic for my womanhood, my body size and shape, and its power. I am no longer apologetic for my sexuality, my feminism, my intellect, my faith, and my difference. All of these parts of self-story stem from She.

I have stared directly into the fourth Face of the Goddess. I have acknowledged Her supremacy as every part of me was changed, as grief and loss altered me at a cellular level. There will always be this watershed in my life—before becoming a mother and after, before death and after. To know Her was to carry that simultaneously and to understand fully the intimacy of life and death as held within the body of a woman, carrying all that potential at once.

Life is to me the years-long period of unfolding within the body of the Goddess, wherein we grow not just physically—feeding on her bounty and taking sustenance from the land, the sea, and the air—but as spirit beings and bodily spirits, not spirit cloaked in flesh but spirit as all flesh, all life. To live as a woman is to be essentially female and to experience the ecstasy of that femaleness, of the sheer power of what some call our physicality but which cannot be separated from the divine. We are Goddess, carrying all the potential of life and death and the great power within us, that same power that births the stars and makes the pull of the tide. The Goddess we are is evident in the rush of spirit at orgasm and at birth, during prayer and ritual, or when soul manifests itself perfectly in the flow of connection and work. Far from seeing my soul and my wondrous body as separate, I have finally realized that they

are one and the same thing. The power released in Circle is the same power of orgasm and the same power of birth; it is the rush of love for the child in my arms, the lover in my bed, and the friend at my side.

That is not to say that I believe, in any way, that the only expression of woman is as mother—far from it. We have a choice. We are living flesh, which embodies every face of the Goddess—birth, death, life, nurturing, abandonment, destruction, construction, and communion. It was Cyhiraeth, the Goddess of Rivers and Streams, that taught me about letting go and letting be, but Cyhiraeth is monstrous and wild, and we too are monstrous and wild and can bring destruction as easily as we bring life. We are many.

From the day the Goddess claimed me as her own, it has been that Great Mother goddess, the First goddess, the First wonder, who has stayed with me. I see all other aspects of She as emanating from this original goddess form. "Mother" to me is about what Adrienne Rich describes as the "potential relationship of any woman to her powers of reproduction" (7), whereas she defines motherhood as an "institution," with all of the limitations associated with that word.

Duality and potentiality are always there. It is there in every step of my halting and, at times, meandering career path, as I fight within an oppressive medical system to espouse the true philosophy and meaning of a midwife to be with a woman, with the womb, with Her, and with Goddess. I strove (and often struggled) to see every woman as a face of the Goddess. I did not always succeed. It is there in my inability to always reach through "the male theoretical attitude towards birth" (O'Brien 21) and to truly foster women's autonomy and empowerment.

That potentiality and duality is there in my approach to parenting, always referring to the Goddess and to the lessons she has taught me— the most important of which being that nothing is promised, nothing is certain, and every day with my living son is a precious one. My relationship with Her was not what I had expected. I had connected with the Maiden but not the virginal, youthful, and slender version I continue to see represented throughout neopagan art and symbolism. I connected with a Lillith-like figure, wild and untamed, a body with curves and strong muscles and physical presence. Defiant, even now, after all these years, I am still She. I had connected with the Crone, bypassing the Mother swiftly. It was as if the Great Mother was showing me every one of life's potentials in a short period of time. She demonstrated with great

force that as woman and as priestess, I carried all of Her within me and must be prepared to manifest all aspects of Goddess at any point in time.

The overarching theme, from that moment to this, has been trust—trust in the Goddess, that I will ride the storm and surf the wave and follow the flow, and that She will always, always keep me afloat.

The Goddess, no matter how you see Her, is the All-Mother, the place of birth and the repose beyond life's end. She is the Earth that holds us, the food that nourishes us, the hand of the healer, and the scythe of the destroyer. She is midwife to each woman who seeks something beyond the persistently negative stories she has been told, all her life, that she is not enough—not good enough, not thin enough, not pretty enough, not feminine enough, not giving enough. She brings to birth feminist, gender inclusive, and spiritual consciousness that connects us with something far beyond the limited version of reality we are currently sold by capitalist social systems fully invested in keeping us dissatisfied and unhappy. The Goddess is a generative and disturbing force for change. She is known to bring destruction before granting new life and to break us down so that we can rebuild. This cycle of death and rebirth, past and present, has characterized the story of my life. And I know that for my future, She will characterize every aspect of growth and change that matters, and that one day I will return to Her embrace having lived my life knowing Her love. As Farrar writes, "For behold, I have been with thee from the beginning, and I am that which is attained at the end of desire" (Farrar 194).

Works Cited

Aune, Kristin. "Much Less Religious, A Little More Spiritual: The Religious and Spiritual Views of Third-Wave Feminists in the UK." *Feminist Review*, vol. 97, no.1, 2011, pp. 32-55.

Bruner, Jerome. "Life as Narrative." *Social Research*, vol. 71, no. 3, 2004, pp. 691-710.

Buckley, Sarah J. *Homornal Physiology of Childbearing: Evidence and Implications for Women, Babies and Maternity Care.* Washington, D.C.: Childbirth Connection programs, National Partnership for Women and Families, 2015.

Einion, Alys. *Inshallah.* Honno, 2014.

Einion, Alys. *Ash.* Honno, 2018.

Estes, Clarissa Pinkola. *Women Who Run with the Wolves.* Rider, 1992.

Farrar, Stewart. *What Witches Do: The Modern Coven Revealed.* Coward McCann Inc., 1971.

Hautman, Dick, and Stef Aupers. "The Spiritual Revolution and the New Age Gender Puzzle: The Sacralization of Self in Late Modernity (1980-2000)." *Women and Religion in the West: Challenging Secularization* (n.p.), edited by K. Aune et al., Ashgate, 2008.

Jencson, Linda. "Neopaganism and the Great Mother Goddess: Anthropology as Midwife to a New Religion." *Anthropology Today,* vol. 5, no. 2, 1989, pp. 2-4.

Mcilveen, Peter. "Autoethnography as a Method for Reflexive Research and Practice in Vocational Psychology." *Australian Journal of Career Development,* vol. 17, no. 2, 2008, pp. 13-20.

Neitz, Mary Jo. "Queering the Dragonfest: Changing Sexualities in a Post-Patriarchal Religion." *Sociology of Religion,* vol. 61, no. 4, 2000, pp. 369-91.

O'Brien, Mary. *The Politics of Reproduction.* Routledge and Kegan Paul, 1981.

Rich, Adrienne. *Of Woman Born.* Norton, 1976.

Sjoo, Monica, and Barbara Mor. *The Great Cosmic Mother: Rediscovering the Religion of the Earth.* Harper and Row, 1987.

Spry, Tami. "Performing Autoethnography: An Embodied Methodological Praxis. *Quaitative Inquiry 2001* vol. 7, no. 6, 2001, pp. 706-32.

Valiente, Doreen. *Witchcraft for Tomorrow.* Robert Hale, 1978.

Section II

Scholarship from Pagan Goddess
Motherlines

Chapter Six

Pagan Mothering, Body Sovereignty, and Consent Culture

Christine Hoff Kraemer

As a theologian, a teacher, and a parent, I often find myself asked to explain contemporary Pagan beliefs and values. Key to these explanations is the concept of paradox—an apparent contradiction that may obscure a deeper truth.

For many Pagans, personal autonomy is a spiritual virtue and a human right. Known for their passionate quests for self-actualization, Pagans seem to march to the beat of their own drummer and pursue lifestyles and spiritual practices different from the norm. Yet Pagans are also deeply invested in the idea of community. Many Pagans long for strong family and even tribes—networks of like-minded groups who provide support and a sense of identity in a time of political upheaval and climate change.

These priorities, while superficially in conflict, are really part of a single ideal, a community whose norms maximize the personal autonomy of each individual. Through empathy, good consent practices, and the cultivation of self-knowledge, Pagans seek personal and spiritual freedom while maintaining loving, committed relationships of all kinds. These efforts sometimes fall short, of course. Like all religious communities, Pagans are human, and their communities are imperfect. To embody the paradox of personal freedom in community, however, is part of many Pagans' vision for their lives.

Sovereignty in Paganism

Contemporary Paganism is not a religion but rather a diverse religious movement under which a wide variety of religious traditions are gathered. People who identify as Pagan or who attend Pagan groups are likely to honour multiple deities, believe that divinity is present in the material world, take inspiration from pre-Christian and/or Indigenous religions, emphasize ritual in their practice, and trust in personal (especially bodily) experience as a source of divine knowledge. These attitudes are not a litmus test for who is a Pagan, however. In many eclectic Pagan communities, there is no boundary to membership beyond self-identity and the desire to affiliate with other Pagans.

Pagan communities often include members of different Pagan traditions, such as Wicca, Druidry, Heathenry, and various reconstructionist Polytheisms. These traditions have specific bodies of liturgy, lore, and practice. The terms that Pagans use to speak of personal autonomy depend on what tradition(s) they practice or are most influenced by. For example, Wiccans, whose liturgy "The Charge of the Goddess" calls them to show they are free from slavery, may speak simply of freedom. This is understood as a state that is not just physical, but also spiritual and psychological—one that allows the practitioner to cast off unnecessary forms of social restriction. In Wicca, unnecessary social restrictions include those that cause us to feel ashamed of our bodies and of our sexuality, which are seen as natural and a gift from the gods. This notion is similar to the New Animist understanding of wildness. For Pagan animists, whose focus is on ecological relationships, to embrace one's wildness as a human animal is to be spontaneous, fierce, and self-reliant, unhindered by negative cultural conditioning and fully in control of one's body.

For many Pagans, freedom from negative cultural conditioning comes partially through uncovering one's own authentic spiritual nature. In Pagan traditions that are influenced by Western esotericism, the term "will" or "true will" (sometimes capitalized to differentiate it from mere whim) is the unfolding purpose of a life in conversation with the divine. Rather than being based on the ephemeral desires of the moment, true will is expressed in the work of a lifetime—for example, the effort to love and be loved, to make beautiful or useful things, or to create justice in the world. Without knowledge of one's true will, a person's choices are not truly free. Rather, their choices are conditioned by social

expectation, which may stifle the individual's talents and leave them frustrated, anxious, depressed, and out of touch with their own divine nature. In Anderson Faery witchcraft (sometimes spelled Feri), the term "self-possession" describes the full internalization of this divine nature. Until the divine part of the self is integrated with the whole, one cannot be said to be truly self-possessed and fully in control of one's being. Druids often use the term "sovereignty" to describe a similar spiritual state. In Irish mythology, a deity grants legitimate rulership or sovereignty to a king or queen, who is then identified spiritually with land and nation. For modern Druids, however, sovereignty is a spiritual possibility for all practitioners—a state of self-governance that necessarily occurs in relationship to deity, land, and community.

Although Pagans are concerned with personal autonomy in general, bodily autonomy, sexual justice, and reproductive rights tend to be special focuses for Pagan activists. The art of putting these principles in practice is called "consent culture," which is a community-based effort to support individuals' personal autonomy while also developing the empathy needed to maintain community cohesion. I was honoured to coedit the collection *Pagan Consent Culture* with my colleague Yvonne Aburrow. The collection gathers essays from Pagans of different traditions, sexual orientations, gender identities, and ethnic backgrounds and describes how they situate consent practices within their particular theologies. I offer it as a resource for anyone seeking to understand this aspect of Pagan belief and practice more deeply.

For the purposes of this chapter, I have chosen the term "sovereignty" to describe Pagan theological approaches to personal autonomy. While this term has special weight in Druidry, I find it is usually understood by other Pagans and benefits from being in common English usage.

Pagan Mothering

For me, mothering is a gendered style of parenting that can, never-theless, be performed by people with a variety of gender identities. In preparing for this chapter, I looked up "mothering" in several English-language dictionaries. I was struck by how little mention there was of women per se, and how much focus there was on care, affection, kindness, and tenderness. I found myself reflecting on the terminology of my witchcraft tradition, in which one's initiator is known as one's "Oathmother," regardless of gender identity. For my own initiator, a

gay man from the generation before mine, "Oathmother" is a perfect term—his affectionate spiritual guidance birthed me into our shared tradition, and his care of me as a person includes remembering my favourite foods and coming over to wash my dishes when I'm ill. Although there are many ways in which he has been like a parent to me, the word "father" simply does not ring true.

In my personal journey as a parent, I have felt most like a mother when engaged in caregiving with close physical contact: breastfeeding, treating cuts and scrapes, soothing my child to sleep. I associate mothering with nurturing the whole human child but most especially the flesh. Helping children and adolescents build a sense of personal sovereignty is an important issue for Pagan parenting in general, but for those who mother, body sovereignty is a special concern. We want our children to feel fully present in their bodies and able to set their own boundaries with the expectation that those boundaries will be honoured. We want our children to come to adolescence and to sexual awakening knowing that sexuality is holy and with the knowledge to make safe and healthy decisions about their desires. And above all, we want our children able to honour others' body sovereignty and to relate to others with empathy and compassion.

Yet helping children cultivate a sense of personal sovereignty is not an easy task. Effective parent-child relationships are inherently hierarchical, with parents giving consent on their children's behalf for nearly every important decision (for example, to medical care, to participation in a school or other educational environment, and to their living conditions). Yet without opportunities to have their boundaries honoured and to give and refuse consent, children cannot develop a sense of bodily or spiritual autonomy. All parents struggle with the question of how much freedom and privacy to grant their children, but for many Pagans, this is the primary question of their children's spiritual development.

Children and Touch

Most Pagans see physicality in general, and the human body in particular, as a manifestation of divine life force. Pleasure is treated as a gift, and the enjoyment of pleasure is part of the purpose of our embodiment. Loving touch, however, is more than a gift or a pleasure. It is necessary for health, especially for children.

Children, and especially infants, need pleasurable touch in order to develop biologically. Human infants who do not experience loving touch often simply die. In the nineteenth century, several studies were conducted on urban orphanages where the rate of infant deaths from a mysterious wasting disease sometimes approached 90 per cent. In these understaffed orphanages, although the infants were kept clean and fed, there was rarely time for the staff to pick up, hold, or play with them. Researchers were stunned, then, to find that infants who were picked up and lovingly cuddled would either recover from or never develop the wasting disease (Montagu 97-100). Today, hospitals and orphanages know that touch is a necessity, not a luxury, for infant care. Although the need for touch becomes somewhat less of a life-and-death issue in older children, touch deprivation is correlated with aggressive behaviour in both children and adults, and touch therapy, such as massage, has been effective in treating disorders such as anorexia, anxiety, and depression in adolescents (Field 61).

Knowing that children need loving touch, and lots of it, to develop normally, we should be disturbed by the way schools are eliminating touch opportunities outside of the immediate family—for instance, forbidding elementary school teachers to hug their students and punishing children for holding hands while in school. We all share concerns about inappropriate touch and abuse. But it is important to remember that neglect is abuse as well and that touch deprivation causes suffering.

Revisiting Hierarchy

Feminist theory and theology of the late twentieth century sees abuse and exploitation of women, children, and minorities as caused by rigid patriarchal structures. This view has led many feminists to become hostile towards hierarchy in general. Nonpeer relationships are seen as inherently compromising the legitimacy of consent to pleasurable touch. This presents real challenges for Pagan mothering. Feminist Pagan parents may find themselves honestly wondering how their children can grow into sovereign adults while being raised in a society so riven with social and economic inequality. With every relationship affected by power dynamics around race, class, gender, age, and more, how can we establish genuinely peer relationships in which to experience healthy sensuality?

In the early part of the twenty-first century, however, some feminists are questioning the assumption that relationships with power dynamics are inevitably exploitative—a view that, for some, is informed by the experience of motherhood. This is Christian ethicist Cristina Traina's strategy in her book *Erotic Attunement: Parenthood and the Ethics of Sensuality between Unequals*. For Traina, the relationship between a nursing mother and an infant is one of the most deeply erotic relationships a human being can experience—and it is also one of the most unequal, with the infant utterly at the mercy of its mother, unable to set any boundaries around sensual touch. Yet we tend to view the mother-infant relationship as one of the most desirable and important kinds of bonds that human beings can experience. Without a loving physical relationship with a caregiver in early childhood, children may develop attachment disorders that prevent them from engaging in physically affectionate relationships for the rest of their lives. Traina also describes how, despite the fact that it is normal—in fact, universal—for mothers, fathers, and other caregivers of children to receive sensual pleasure from their relationships with children, it is utterly taboo to acknowledge this pleasure. This reality suggests there is a problem in our thinking: about pleasure, about children, and about power dynamics.

Traina argues that if the loving, sensual touch exchanged in the mother-infant relationship is healthy, desirable, and necessary, then erotic relationships in a power dynamic cannot be inherently unethical. Provocatively, she writes:

> The eroticism of maternity is widespread and inevitable. If erotic, or even sexual, maternity is not categorically perverse, we must revise our ideas of eroticism, sexual pleasure, and mothering in order to account for it.... [It] will necessitate revising our most basic descriptive claims about sexuality and reexamining cultural norms that reserve sexual pleasure for relationships between equal adults, possibly forcing us to reconsider the character of the line between appropriate and condemnable eroticism between unequals in general. (11)

Traina questions the idea that pleasurable touch should not occur between non-peers—and, in fact, if children are to receive the touch they need to develop, it must occur. Looking to resources such as massage therapy ethics and feminist theology for resources, her book explores

possibilities for protecting the vulnerable from violation and for fostering healthy touch.

Neglect through touch deprivation and child sexual abuse are both abhorrent realities in our society. Accordingly, we are called to think deeply about touch ethics, especially about touch involving children. The characteristics that make touch boundary violating and abusive must be carefully described so they can be identified and avoided. But the awareness that touch deprivation is also damaging means we must reject our society's standard "no touch" policies for preventing child sexual abuse.[1]

Cultivating Sovereignty and Teaching Consent Culture

I am pleased to report that over the last ten years, there has been enormous growth in publications offering body-positive, sex-positive strategies for teaching children and adolescents about consent and supporting their developing sense of bodily autonomy. In the limited space of this essay, I can offer only a few basics, but I invite the reader to check the bibliography for more detailed resources.

Ask before Touching

Children should be taught both verbal and nonverbal ways to ask for touch. Among those we do not know well, asking verbally before touching is a good idea (for example, saying "Do you want a hug?"). Especially in established relationships, though, asking nonverbally works just as well; we can open our arms for a hug and wait for the other person to mirror the gesture before hugging them. Note that asking is only half of the procedure, waiting for the enthusiastic "yes!" is the other half.

In turn, children should expect others to ask them before they touch. Parents and caregivers can model this behaviour by asking children if they want to be hugged, kissed, or picked up even when they are confident consent will be given. Children who expect to be asked before being touched are more likely to challenge attempts to violate their boundaries. Having clear expectations can help to create teaching moments for other children who may be struggling to honour others' boundaries, or it can draw attention to more seriously inappropriate behaviour from other children or adults.

Children should also be made aware that parents and caregivers do not need permission to touch if a health or safety issue is involved. As any parent who has ever wrestled a thrashing toddler into a car seat knows, it is a parent's responsibility to overrule their child's nonconsent to essential safety procedures.

Honour "No"

Make it clear to children that in your house, using the words "no" or "stop" will cause touching to cease. Do not allow anyone to tickle or noogie or restrain a child who is yelling "No! Stop!", even if the child is shouting those words in fun. Teach your children to take those words seriously and to check in or intervene if they hear anyone else using them. Be clear that even if permission to touch (or tickle, or noogie, or wrestle) was given earlier, it can be withdrawn at any time.

Let your child practice setting boundaries by stopping promptly when they say "no" or make a game out of accepting and refusing touch (Kraemer, *Teaching Consent Culture*). If your child tells you to stop while you are touching them because of a nonemergency health or safety issue, pause and tell them that you heard their "no" but that you need to continue for their health or safety (or someone else's).

Sometimes, the health and safety issues are yours or the whole family's, not specifically your child's. Often, my preschooler is too young to realize how his actions affect others. If I ask him to leave the playground and he says "no" and runs away, my explanation that we have to leave so I can eat, rest, or care for another family member may not change his mind. Although gentle parenting methods such as coaxing, persuading, and redirecting are preferable, with some children nothing less than carrying them away screaming will work to keep everyone safe. We do our best to honour "no," but we use common sense as well.

In some families, there is a social expectation that children kiss and hug relatives, even against the child's will. Do not force a child to give affection. If this is the norm in your family, have a gentle conversation with your relatives about how important it is that your children learn they have the right to control their own bodies. Although your relatives may not always get a kiss or hug from your child, if they do, they will know for certain that the affection was genuine.

Encourage Empathy Development

Empathy development happens naturally when children participate in long-term, loving relationships. Parents and caregivers can support that growth, however, by talking about feelings with children and helping them find words for emotions. Encourage them to imagine how their actions may affect others. For example, ask them, "If someone pushed you like that, how would you feel?" Try reading stories together and talking about how the different characters felt at various points. Help your child notice that two different characters may feel quite differently about the same situation.

Provide Guidance around Nonverbal Cues

Although it is helpful to encourage children to use their words to communicate clearly, communication also happens on the level of body language. Children have opportunities to begin learning body language consciously when interacting with babies and children too young to speak. When I was a new parent, I was grateful to other parents in my community for modelling this kind of teaching when their children would play with my child. One parent cautioned his daughter as she hugged and bounced the baby: "Listen to the sound he's making; he's saying no, so you need to stop. Now he's smiling because you're being more gentle." Another taught bodily autonomy when she stopped her daughter from jamming the pacifier in his mouth: "We don't force-feed babies. Just offer the binky to him; see if he takes it."

Teaching children to notice and read these nonverbal cues helps them understand that although verbal communication about touch is important, body language is communication too and should not be ignored. Although a child (or adult) may not speak, they still have the right to make decisions about their own bodies and to accept and refuse touch. Parents and caregivers may also find it useful to show young children books and videos that label and identify facial expressions (happiness, sadness, anger, and fear).

Encourage a Sense of Ownership of the Body

The opportunity to make choices about their own bodies helps to build children's sense of control and autonomy. As is developmentally appropriate, support your child in choosing what clothes to wear,

dressing, undressing, grooming, and washing. Try to make it clear that when you assist your child in these activities, it is because they cannot yet perform them on their own. For young children, offering even limited choices can increase their sense of participation and agency—for example, "Do you want to wear the yellow shirt or the green shirt?" or "Would you rather sit in my lap when we brush your teeth or sit on the stool?"

Children are often curious about their genitals. Let them know that their genitals are theirs to touch and that it is okay to touch and look at them in private. Older children, especially preteens and adolescents, should learn about the age of consent as it is defined in your region. Children and adolescents under the age of consent cannot legally give consent for another person, whether a child or an adult, to touch their genitals. In a medical context, parents must give consent for them. In some places in the United States, underage sexual activity—even when both participants are under the age of consent—can have severe legal consequences. Make sure your children understand that although their bodies are theirs to explore as they please, their genitals are private and not to be shared.

Explain the Path towards Greater Freedom of Choice

As responsible parents, we must sometimes limit our children's freedom to choose. They cannot, for example, choose to go without bathing for weeks, eat only Snickers bars, or stay up until three in the morning on a school night. When we find ourselves in a position of insisting our children do something, however, we can talk to them about what responsibilities they will need to take on in order to have freer choices. As Pagan social worker Sierra Black remarks in an interview about children and consent culture:

> If [my kids] want their hair to be long, then they need to either brush it themselves or let me brush it. Or we can cut it. So they may not like any of those choices, but they're being given some insight into and participation in what the choices are ... Even when they were babies, if they didn't want to have their diapers changed, I'd say, okay, when you learn to use the potty then we won't have to change your diaper anymore. I give them a path towards the agency that they want. (380-81)

Explicitly acknowledging the process of taking on more responsibility and acquiring more freedom helps children understand that their parents' rules are deliberate, not arbitrary. Rather than feeling trapped by their parents' authority, children can become aware of their power to increase their own autonomy.

Grow Your Own Sense of Sovereignty

To help our children cultivate a sense of sovereignty, we need to also nurture it in ourselves, which requires practices of self-knowledge and self-care that allow us to be present in our relationships with our children. As Pagan priestess Nadirah Adeye writes:

> Parenting with sovereignty also means that my job, as a mother, is to *do my own work*. My own growth, my own healing, are critical aspects of the parenting process. What I find most effective is having the *capacity* to be responsive to [my son] and what is happening in any given moment: responding to what he needs while navigating the process of balancing his needs and my own. Mothering from a place of sovereignty means belonging to myself and seeking ways, means, and paths that suit who I am as a mother. (370-371)

Just as we must parent the child we have, not the one we wished or thought we would have, each of us must be the best version of the mother that we are, not the one we wished or imagined we would be. Our parenting should play to our strengths and arise from a sense of freedom and joy in who we are.

Finding and Creating Communities That Value Sovereignty

Mothering children is always a challenging task, but without support from extended family and community, it can be isolating and draining. Cultivating sovereignty is something that must happen in the context of loving relationships. For that, we need like-minded others.

Although Pagan communities are one place that parents are seeking to nurture sovereignty in children, there are also secular resources. One such resource is the free-range kids movement, which focuses on promoting independence, resilience, and creativity in children through

outdoor play as well as through opportunities to take on real-world responsibilities appropriate to their age and development. The term "free-range parenting" was coined by reporter Lenore Skenazy, who wrote a book entitled *Free-Range Kids*, and runs a parenting website called *Let Grow*. Skenazy tends to emphasize parents' rights in her writing—the right of parents to raise their children as they choose—but equally important to the movement are the rights and autonomy of children. Interested parents can fill out a form on Skenazy's website to get in touch with other free-range parents in their area.

Because many Pagans practice their religion as solitaries—in other words, without a stable group or community for support—they know what a struggle it can be to maintain values and a family culture that differs significantly from the mainstream. For Pagans and others who want to cultivate sovereignty in their children, it is important to hold on to the vision of sovereignty in community even when that vision seems out of reach. When asked what a Pagan consent culture by and for children might look like, Sierra Black imagined the following:

It would absolutely be rooted in children's autonomy over their bodies, their minds, their feelings, and their spirit. Children growing up in Pagan consent culture would be people raised to consider their own needs in tandem with the needs of others. They would be children secure in the ability to act on their own behalf and therefore able to, in a healthy way, act on behalf of others. It would be a model where those who hold power use it responsibly to protect the health and safety of children and other vulnerable people, and where the kids and everyone else would get to make most of their decisions most of the time. They would always be transparently aware of what decisions are being made for them and why. I think that that would foster a sense of personal power, but also social responsibility. (386-87)

As a Pagan mother, this vision moves me deeply. I want this support, power, and freedom for my child, and I hope for it for all children in my communities. I offer this essay in the hope that it may help Pagan and other families move one step closer to manifesting communities of sovereignty and empathy.

Endnotes

1. For more on the ethics of touch in relationships with a power dynamic, see Kraemer, *Eros and Touch from a Pagan Perspective*.

Works Cited

Adeye, Nadirah. "Self-Possession as a Pillar of Parenting." *Pagan Consent Culture: Building Communities of Empathy and Autonomy*, edited by Christine Hoff Kraemer and Yvonne Aburrow, Asphodel Press, 2016, pp. 361-74.

Field, Tiffany. *Touch.* MIT Press, 2003.

Kraemer, Christine Hoff. *Seeking the Mystery: An Introduction to Pagan Theologies.* Patheos Press, 2012.

Kraemer, Christine Hoff. *Eros and Touch from a Pagan Perspective: Divided for Love's Sake.* Routledge, 2014.

Kraemer, Christine Hoff. "Teaching Consent Culture: Tips and Games for Kids, Teens, and Adults." *Pagan Consent Culture: Building Communities of Empathy and Autonomy*, edited by Christine Hoff Kraemer and Yvonne Aburrow, Asphodel Press, 2016, pp. 389-408.

Kraemer, Christine Hoff and Yvonne Aburrow, editors. *Pagan Consent Culture: Building Communities of Empathy and Autonomy.* Asphodel Press, 2016.

Montagu, Ashley. *Touching: The Human Significance of the Skin.* Harper & Row, 1986.

Skenazy, Lenore. *Free Range Kids: How to Raise Safe, Self-Reliant Children (Without Going Nuts with Worry.* Jossey-Bass, 2009.

Skenazy, Lenore. *Let Grow: Future-Proofing Our Kids and Our Country,* letgrow.org/. Accessed 8 Sept 2018.

Traina, Cristina L.H. *Erotic Attunement: Parenthood and the Ethics of Sensuality between Unequals.* University of Chicago Press, 2011.

Chapter Seven

I Do Not Want to Be a Goddess

Kusumita Muhkerjee Debnath

I work and I wonder. My moments spent alone are the moments I listen to myself—myself as a person and as a woman. I try to see how people see me. I am not a 'good' woman to most people. I often overhear whisperings: "What is a married woman who is also a mother doing at her parents' house? Why has she been here for over five years? Her husband must have left her for good. See how unorganized her home is. She still doesn't cook any meals at home. She is a worthless woman, Alakshmi (the negative counterpart of the Hindu Goddess of wealth *Lakshmi*)."

Figure 1. Goddess Alakshmi

My mother reprimands me often and has been doing so since I attained adulthood. She inspires me with examples of my friends whose homes are maintained like studio apartments. She calls me lethargic because I never pick up the duster to tidy my room. I

guess the whispers must have reached her, too.

My answer to all of this is what it has always been: I hate domestic chores as if a vice. I do them only if I have to. This does not mean I luxuriate in delicious sloth. No. I want to live each moment of my life exploring this beautiful world—gaining knowledge from without and philosophizing from within. Ulysses claimed the same freedom from domesticity to follow knowledge like a sinking star. But if I, a Bengali Hindu woman, aspires towards any such ideal I am branded to be Alakshmi.

I am not a special case. This categorization begins at birth. A boy's birth is announced as it is. No God needs to be named at his birth because being a boy means that his birth will be celebrated by the entire family. No conditions applied. But when a girl is born, it is usually announced in this way: "You should be grateful. Lakshmi has arrived." Girls need a validation the moment they emerge from their mother's wombs, a word of consolation for a family that had been eagerly waiting for a son.

You must be wondering what is so special about this Lakshmi? The first and foremost aspect that makes her desirable to all is that she is the Goddess of wealth and prosperity. The scriptures, as my Grandma tells me, describe her as one so beautiful as to be deserved by only the greatest among the Hindu Gods, Vishnu. In most artistic portrayals, she may be viewed as an ever-smiling consort of Vishnu. Whereas the sustainer of this universe i.e., Vishnu, reclines on the coils of the giant serpent Sheshnaga, Lakshmi is seen to be not only awake but massaging the feet of Vishnu. I wonder at times: So, Goddesses need to serve their husbands as well? This humiliation is not just limited to mere mortals like us.

Figure 2. Goddess *Laxmi* in a servile posture

This description of Lakshmi was so incredible that I was inspired to check on her counterpart Alakshmi. How bad could this Goddess be that she was so undesirable? In *Provincializing Europe*, renowned Bengali postcolonial theorist Dipesh Chakrabarty gives the following description of Alakshmi:

> However she originated, *Alakshmi* came to embody a gendered and elitist conception of inauspiciousness, and the opposite of all that the Hindu lawgivers upheld as *dharma* (proper moral conduct) of the householder. It was said that when she entered a household, *Alakshmi* brought jealousy and malice in her trail. Brothers fell out with each other, families and their male lineages (*kula*) faced ruin and destruction. (227)

This is exactly what my problem is. I could have consulted the *Lakshmir Panchali*—the book of chants to appease the Goddess of wealth, Lakshmi—in the first place. But I had to take up something like Chakrabarty's book. I cannot accept blindly whatever society hands down to me as its norm. Initially after marriage, I was pressured to clean

up my husband's house in the name of upholding the reputation of my parents. I became relaxed, though, while reading Simone De Beauvoir's *The Second Sex*. I especially enjoyed the section where the French feminist discusses that it is ultimately useless to perform household chores, such as cooking and washing, as the effects of both are very short lived. Slowly, my intellectual activities left me little time to be bothered about those chores. In short, I became Alakshmi.

I see lots of women, daily. I scrutinize their lifestyles. I try to sense how well they cut themselves as a figure in the eyes of this society by their incessant labour in the household. Surprisingly, no matter how hard they try, it seems their efforts always fall short of the invisible standards set for them.

Take, for example, my colleague Monali. She is the wife of a reputed physician. I observe that Monali loves to stick to this identity. I fail to understand that, as she herself is a teacher (albeit part time) of microbiology. Why is her husband's identity more important to her? She is late for her classes on most days because she is busy with routine activities, such as cleaning her kitchen or decorating her living room. What difference remains between her and my hired helpwho cooks for me? My cook, by caste and class system, has no access to education or further employment options. In considering caste and class, there are not one but many Indias. The complexity of Indian society is best understood by its massive constitution. Wikipedia details that theIndian Constitutionis theworld's longestfor a sovereign nation, as it comprises more than 395 articles and is divided into twenty-two parts and eight schedules. The Constitution allowed the country to leave behind the evils of the caste system, wherein some citizens are granted rights and privileges beyond and over others. Unfortunately, this conceptually sound document still fails to satisfy the actual needs of the commoners, and the evils of the caste system remain. There is a vast gap between the affluent classes, comprising the higher castes who can educate their children, and those belonging to the lower classes and castes, who often cannot feed their children, let alone afford to educate them. Such children grow up having to reduce the financial burden of their parents by starting to work early in their lives.

Thus, to address this gap between Monali and the behaviour of the educated, perhaps the answer is the ideology of the Stri dharma, which describe the duties of a woman according to Hindu scriptures. *Lakshmir*

Panchali contains certain dictates that every married woman is expected to follow. It gives its own set of norms as Stri dharma. For the benefit of readers, I enumerate a few of the negative qualities in women, which arepointed out as the most undesirable elements by Lakshmi to the celestial sage Narada:

1) Uchcha hasi uchcha bhasa kohe narigan: It is because of women who speak or laugh loudly that their families suffer economically.

2) Sandhya kale nidra jay behosh nayane: It is because women of the house fall asleep in the evening that their families are poor.

3) Jethaysethay kore swechay gaman: Women of the house wander here and there at their own will, and so their families remain poor.

4) Thakite chahe go sada hoye swatantra: Since married women want to live independent lives, their families are poverty ridden.

5) Chariya che grihasthali chereche randhan: As the wife has forsaken domestic duties and even cooking, their families have become financially distressed.

It is, of course, beneficial to lead a disciplined life. But it hurts to know that only women are expected to follow it. If the Goddess is supposed to grace the entire household with wealth, then why does the woman alone bear the responsibility of ascertaining whether or not the entire household receives this bounty? I am surprised beyond measure when I read that the *Book of Lakshmi* instructs women to pray to have only male children. How can a scripture, a holy text that is dedicated to a Goddess, instruct mothers to prefer male children? I suppose it is because of such prevalent ideas that our sweeper woman, Chintamani, comes to work even at the ripe age of seventy. She suffers from chronic asthma. She pants vigorously after barely taking ten strides, yet she appears week after week for work. When I ask her to send her son instead, she says that as long as she can, she will work and save her son the bother. This all-pervasive mentality wrings my heart. I try to find answers, and when I do, I am dumbfounded.

I read chapter eight, "Family, Fraternity and Salaried Labour," of Dipesh Chakrabarty's *Provincializing Europe*. I find that the eminent postcolonial critic has unmasked the vendetta of Bengali men against women that they had wielded through the glorification of the Griha Lakshmi.[1] Chakrabarty points out that although Bengali men protested

the office work handed out to them by their British masters, they demanded hard work from their women. They hailed housewives as Griha Lakshmis and made them subjects of poetry. The reality was that they wanted dedicated slaves who would be happy with fake tags of glorification. I quote the following passages as examples. The first passage states the dissatisfaction with office work among Bengali men using Rajnarayan Basu's *Shekaal ar ekaa* as a case in point. Writing in 1874, when the author RabindranathTagore was still in hisearly teens, the Bengali intellectual Rajnarayan Basu complained:

"We can never work as hard as the English.... The English style of exertionis not right for this land. The custom that the present rulers have introducedof working continuously from ten to four is not at all suited to thiscountry. The body is quickly exhausted if one exerts oneself when the sun is still strong"(qtd. in Chakrabarty 214).

The second passage stresses how contemporary educated women avoided domestic chores in favour of hired help:

In fact, the same Rajnarayan Bose who complained that office work for men was too severe under British rule, alsocomplained about "modern" Bengali housewives who did not work hard enough: "These days, women in well-to-do families are entirely dependenton [the labor of] their servants and are averse to *grihakarya*. Thewomen of older times were not like that....The educated women of ourcountry now are reluctant to do physical labor or *grihakarya*." (Chakrabarty 214)

This kind of scandalizing of any woman who shirked domestic chores was and still is a powerful weapon in the hands of the dominant order in Indian society. This dominant order is not limited to men alone; it permeates all segments of gender, caste, and class, so much so that the contemporary woman is mindful of the scrutinizing gaze that may forever tarnish her image of a perfect woman. Take, for example Priyam. She is an electrical engineer working for a reputable firm. We hardly keep in touch because of her family commitments, even though we were best of friends at school. She makes it a point to reach home by six in the evening at the latest, which has had a negative affect on her work. But she simply cannot let the housework go undone. She returns because the nanny of her child leaves around that time. On the rare occasions I talk to her, I urge her to stay calm and take things easier. Try involving your

husband, I suggest. She grunts in disapproval. She says that she could not trust her husband on household matters.

What nonsense! Men and women can both be able housekeepers. Hotels are run by male and female employees alike. They require skills such as cooking and cleaning. Are they not like household jobs? If men can perform there, why not at home? Some people will argue that hotel employees are trained for the job. Yet are women born with housekeeping skills? If so, then the entire hospitality industry would have to be run solely by women.

When I watch stereotypical portrayals of women washing clothes for their husbands in contemporary Indian television advertisements, I get very disturbed. I keep deliberating as to how Indian women have been brainwashed over generations into believing that performing meaningless routine tasks is the only way they can achieve desirability and respect in the eyes of the opposite sex. In fact, in Rabindranath Tagore's novel *Choker Bali*, the female protagonist, Binodini, is reprimanded time and again by the other women characters and reminded that it was because of her education she had had to suffer widowhood. Amazing isn't it? In order to restrict women to the home and hearth, what ridiculous propaganda some patriarchal Hindu priests have advanced—that women's education reduces her husband's lifespan!

If the men in our families are inefficient as housekeepers, it is not solely their fault. The blame also goes to their mothers, sisters, and wives as well. During my school days, I often observed the total dependence that boys most often had on their mothers and even on their sisters. We used to stay in a house opposite to the Mukherjee's. They had two kids. The boy, Jatin, was my age, and the girl, Ria, was younger. The boy was a nice guy. I hate saying this, but his mother spoiled him: He was never allowed to make his bed or pack his own lunch.

I heard his mother shouting at him whenever he argued with her on this: "You don't have to worry about all these things. Boys should only study at this age. You have got to make us proud. If you do not grow up to be a doctor or engineer how will you look after us when your father retires from service?"

"But Ma, I don't like the way Ria makes my bed," the son replied.

"Okay. I'll talk to her. Your sister is just too idle. She never takes these tasks seriously.

Whenever I ask her to tidy up, she makes a face at me and runs. She

must learn this for her own good. Otherwise, who will marry an Alakshmi?"

"Yes Ma, teach her a lesson. But Ma, why can't I pack my own lunch? You are already so busy. I can at least help you out by packing my lunch."

"Boys don't do all this stuff. Now I am doing it for you; later, your wife will."

No wonder most Indian men have grown up thinking that women have been created by God just to serve them. Feminist economists have delineated time and again how economic dependence of women on their fathers and husbands has been the major factor behind their marginalization. This marginalization in India is sanctioned and promoted through religious texts, such as the *LakshmirPanchali*.

While researching about feminist economics, I happened to come across the cover page of the very first issue of *Ms.* magazine:

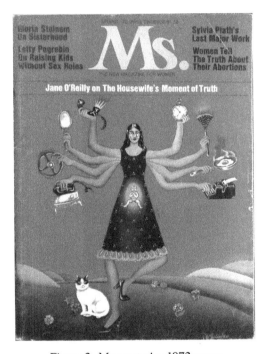

Figure 3. *Ms.* magazine 1972 cover

This cover depicts a woman with eight hands and a cat near her left foot; she resembles a Hindu Goddess, which traditionally has the tiger under her foot. In her hands, instead of weapons, there are household

items—such a frying pan, a broom, a spoon, and an iron—as well as professional items, such as a typewriter, a steering wheel, a clock and a telephone receiver. This cover is interesting on many levels. Most importantly, the cover uses a Hindu Goddess–like entity to represent the struggles of women. This signifies, in my view at least, that the Western academics publishing this magazine viewed Hindu Goddesses as icons of female subjectivity. Second, the tears in the woman's eyes highlight how women have a tough time managing household chores and professional responsibilities, which is contrast to the usually indomitable and fearsome aspect of Hindu Goddesses.

The *Lakshmir Panchali* advocates that women should never argue, especially with elders. Thank goodness I had never been a slave of such adverse doctrines. If I had been, this essay would have ended differently, and I would have continued with my negative musings against the Hindu Goddess Lakshmi. Since the cover of the *Ms.* magazine had disturbed me so greatly, I took it to college. I wanted to know the opinion of the head of the English Department, Sri Indrajeet Bandyopadhyay, about this image, so in 2014, I asked him. Professor Bandyopadhyay had been researching Hindu mythology and the *Mahabharata* for the last decade. Some of his eminent publications include *Mahabharata Folk Variations* (2013) and, *Mahabharata: The Woman's Life Story* (2013).

I showed the image to him and asked his opinion on the way in which the West acknowledges that we Hindus always offer subservient positions to women. Even the Goddesses are not an exception to this rule—right from Lakshmi, who massages Narayan's feet, to Kali who sticks out her tongue in shame when she places her foot on her husband's body.

The professor gave me a look of "You should have known better" and then suggested that I read the *Mahabharata* personally to realize how the devil has cited the scripture to suit his purpose or, to be more specific, has misinterpreted the scripture to suit his purpose.

Reading the vacant look in my face, the professor chose to illustrate his point further. He spoke about the Vana Parva of Mahabharata, the part in which appears the dialogue between Kunti and Surya, where the former explains stri dharma[2]: "For protection of body, woman uses her sexuality—and that performance is part of Kuta Dharma and Apad-harma."[3] Therefore, he suggested that being the good wife and the good daughter are not the only aspects of Hindu womanhood.

I tried to counter him by saying that the *Lakshmir Panchali*, also a

Hindu text reeks of male chauvinism. He could not but agree but further added that those kinds of manipulative texts had been produced at a large scale at the time. He said that although its origins are unknown, one thing is sure: it had been manufactured at a much later age than any of the Vedas or Puranas. He proposed that I treat the Panchali as a specimen of the grand narratives that postmodernism puts to question.

I did not know how to reply. I made my way into the library trying to sort out all that I had just heard. I found myself uselessly staring at the nineteen-volume magnum opus *Mahabharata* that was resting calmly in the shelf mocking my puny self. I questioned myself, did I have the mettle to go through this entire epic to sort out all my queries regarding the position of women in Hinduism? I felt that I would be tossed and turned like a small vessel in the stormy sea of such vast knowledge. I was about to give up on my pet project when I happened to find a book called the *7 Secrets of the Goddess* by Devdutt Pattanaik.

I looked further and found Pattanaik's book called *Sita*, which is the retelling of *Ramayana* and *Jaya*, itself the retelling of *Mahabharata* also by the same author. The books caught my attention immediately, since Pattanaik is the bestselling author of books on Indian mythology. His works tend to simplify the Hindu texts and interpret them in a coherent yet comprehensive fashion for the modern reader. In an interview given to *Indian Express* in 2018, Pattanaik claims that it is his aim to "make knowledge accessible."

The fifth chapter of Pattanaik's *Sita* was a revelation itself. Entitled "Sulabha and Janaka," it delineates an episode in the life of Sita's father, Janaka, that had been originally described in the *Bhisma Parva* of the *Mahabharata*. At the beginning of *Ramayana*, when four daughters are born to the two royal brothers of Mithila, Janaka as the King of Mithila resigns to his destiny of having only daughters. It is at that time a mysterious and sensual woman, Sulabha, comes to meet Janaka. When she sees that Janaka fails to fathom her mind and is seduced by her body alone, Sulabha says: "We both see the world differently, not because we have different bodies, but because we have different minds. You see the world from one point of view and I see the world from another point of view. But our minds can expand. I can see the world from your point of view and you can see it from mine" (17).

We are in the twenty-first century, and we are still debating feminism and gender sensitization, even though Valmiki wrote about it already

thousands of years ago in his *Ramayana* from the second-century BCE. I had been such a numbskull—fooled by popular culture. Had my curiosity not been provoked, I would have kept the same stigmatized view of Hinduism till death.

We all know that basically *Ramayana* is the story of Ram, who is an incarnation of Vishnu, whereas Sita, his wife, is the incarnation of Lakshmi, the celestial consort of Vishnu. The central conflict arises when due to the evil designs of his stepmother, Kaikei, Ram gets banished with Sita and half brother,Lakshman. Then,Sita is abducted by the demon king of Lanka, Ravana. A battle ensues, and according to common knowledge, Ram kills Ravana and carries Sita back with him. But Pattanaik points out the reference to Adbhut Ramayana written in the fourteenth century in which the battle ends in a different way. After killing Ravana, Ram and Sita are leaving Lanka, when they were stopped by Ravana's twin. Pattanaik writes: "Before Ram could reach for his bow, everyone saw an incredible sight. Sita suddenly transformed.... It was a fierce battle, the Goddess with her many arms pounding the demon who dared interrupt her union with her husband. She ripped his entrails ... drank his blood" (253-54). In the footnote to this episode, Pattanaik writes that this notion of Sita herself killing Ravana can also be found in Sri Vaishnava literature. There, Sita is described as having the potential of killing Ravana on her own: "She was the independent Goddess who had made Ram the dependable God" (254).

This fearsome Sita was not included in the original version but was later added in the *Adbhut Ramayana*. But the fact remains that it was added and in the fourteenth century no less. Both the *Ramayana* and the *Mahabharata* have been rewritten and reinterpreted many times. The pertinent issues of the times became entwined with the main narrative that Valmiki had scripted.

Something similar happened with *Mahabharata*. This epic has received much criticism for its depiction of staking women in a game of dice as if they were property. That is why in South India, Draupadi is worshipped as the fierce virgin Goddess who is let down by her five husbands. And in the *Bhil Bharata*, a version of the *Mahabharata* from the Dungri Bhil community in the northern part of Gujarat, there is a tale of the Pandavas being asked to find "a man who is sold by a woman" before they can proceed with a fire sacrifice. They fail to find such a man. Finally, a prostitute sells them one of her customers. This tale by Dr

Bhagwandas Patel points out the moral outrage that the staking of Draupadi had caused (Pattanaik, *Sita* 150).

My readings proved once again that mini narratives lie embedded waiting to be unraveled by curious minds. But my curiosity was not yet satiated, so I picked up Pattanaik's*7 Secrets of the Goddess* to look deeper into what Lakshmi signified in Hinduism. As I have already written, Lakshmi is the Goddess of wealth. In Hinduism, as in any other religion, wealth is an ambiguity, as it is both a necessity and a vice. A society's perception of Lakshmi, thus, varies with its attitude to wealth. As Pattanaik explains: "In the early part of the Vedas indicated by Brahmana texts, we find hymns and rituals about acquiring and celebrating wealth....In the latter part of the Vedas indicated by the Aranyakaand Upanishad texts, we find a great discomfort with wealth" (175).

I had never tried to understand Lakshmi in this respect. It is a fact that wealth satisfies, but greed for the same reason can also be fulfilling. So, in a way, even a Goddess is not above censure. But the critical point is to understand that it was impossible for the Hindus to point out the vices of a Goddess, even though they had come to perceive that greed for wealth could ruin humans. At this juncture, the figure of Alakshmi appeared. Pattanaik observes her appearance in the Puranas written much later than the Vedas:

> In the Puranas (which was derived from Vedanta which itself had been inspired by the Vedas), we learn of *Lakshmi*'s elder sister, *Jyestha*, also known as *Alakshmi*, who always accompanies her. She is the goddess of strife. She is the reason why the prosperity of *Lakshmi* is never accompanied by peace. The only way to get peace into the household is to discover and invoke either *Shiva* (the ascetic who has outgrown hunger) or *Vishnu* (who balances the shortcomings of *Brahma*'s sons such as *Indra* with the possibility offered by *Shiva*), then *Alakshmi* does not accompany *Lakshmi*, and so wealth is not accompanied by quarrels. (*Seven Secrets* 177)

Now was the time for me to rethink. So, if Lakshmi can only be achieved through Shiva and Vishnu, does it mean a female deity can never deliver the desired results on her own and needs the validation of a male God? No. That is not the case at all. Such an interpretation would be as biased as the *Lakshmir Panchali* itself, which is nothing more than

a repressive tool created by a few patriarchal scholars. As Chakrabarty states, "Ever since printing technology became available, books carrying stories of *Lakshmi* and *Alakshmi*, meant for use by women in ritual contexts, have been in continuous supply from the small and cheap presses of Calcutta" (227).

As an enlightened individual, I tried to rise above the dominant discourse and reinterpret *Lakshmi*. When I did, I found that I had arrived at the implied meaning of Lakshmi massaging the feet of Vishnu. It was hardly a valorization of a woman's duties to her husband. On the contrary, the image is a poignant metaphor that had been deliberately misinterpreted. The image signifies a philosophy that is common to all major religions of the world. The reclining Vishnu is the image of a human being who is at ease with oneself, whereas Lakshmi massaging his feet is nothing but the subordination of worldly desires before the achievement of peace in the oceanof troubles—since Vishnu is depicted as lying on Sheshanaga under an ocean.

I feel sorry that even though I have taken the pains to comprehend the nuances of my religion, most people will continue with their false presumptions in the name of tradition. Right from Priyam and Monali, to my sweeper maid, women refuse to question tradition. As for me, I can only say I do not want to be a Goddess, neither Lakshmi nor Alakshmi. I feel emancipated having unravelled these Goddesses as poignant metaphors rather than complacently accepting them as subservient female deities at face value.

Endnotes

1. Griha Lakshmi: She is not a Hindu Goddess. Rather, in Hindu culture, any woman who is accomplished enough to be regarded as the perfect housewife is called Griha Lakshmi. She is likened to the Goddess Lakshmi because she creates the perfect ambience of luxury and comfort in the household, similar to what Goddess Lakshmi is supposed to bless mortals with.

2. *Stri Dharma*: Duties of women, married or otherwise.

3. Kuta Dharma or Apadharma: The duty of human beings that pertains to the utilization of their intellect for materialistic gain.

Works Cited

Bandhyopadhyay, Indrajeet. *Mahabharata Folk Variations*. Lulu, 2013.

Bandhyopadhyay, Indrajeet. *Mahabharata: The Woman's Life Story.*Lulu, 2013.

Basu, Rajnarayan. *Shekaalarekaal*. BalmikiJantra, 1874.

Beauvoir, Simone de. *The Second Sex*. Bantam Books, 1952.

Chakrabarty, Dipesh. *Provincializing Europe: Postcolonial Thought and Historical Difference*. Princeton University Press, 2000.

Indian Express Adda. "Devdutt Pattanaik: Modern People Want to Feel Liberal, so They Construct a Past That's Conservative." *Indianexpress*, Oct 27, 2018, indianexpress.com/article/india/devdutt-pattanaik-modern-people-want-to-feel-liberal-so-they-construct-a-past-thats-conservative-5420504/. Accessed 26 Nov. 2020.

Pattanaik, Devdutt. *Jaya: An Illustrated Retelling of the Mahabharata*. Penguin Books India, 2010.

Pattanaik, Devdutt. *Sita: An Illustrated Retelling of the Ramayana*. Penguin Books India, 2013.

Pattanaik, Devdutt. *7 Secrets of the Goddess*. Westland, 2014.

Tagore, Rabindranath. *Chohker Bali*. 1903. Random House, 2012.

Chapter Eight

The Path of the Cold Hearth-Stone: Reflections on Sex, Saturn, and Solitary Working

Georgia van Raalte

In this chapter, I explore the twentieth-century occultist Dion Fortune's claim, made in *The Training and Work of an Initiate,* that one cannot be both a mother and a magician. I consider the social reasons for which Fortune advanced this idea, including her awareness of the dangers of occultism in the interwar period and her desire to create a form of magic that was accessible to middle-class women. I consider Fortune's work with Mary Stopes and early contraception to understand why she believed motherhood was a matter of choice and karma. I then relate this to my own experiences as a mother and a magician. Rejecting Peter Gray's fetishistic approach to magical sexuality, I explore the way that sexual liberation has created a demand that all women be sexual while removing the social safety nets that surrounded the concept of family. I argue that the importance of family and motherhood have been lost from much of contemporary occultism and that sexuality, motherhood, and family should not be considered separate categories. Thus, I attempt to establish a new approach to magical motherhood—one that values the negative experiences of motherhood as much as the positive and considers depression and the abyss of motherhood as holy, too.

High Magic, Paganism, and the Occult

Occultism and high magic are often termed forms of Paganism. However, as Susan Greenwood argues, this is problematic because Paganism is an "umbrella term" for a group of magical practices, which are often seen to predate Christianity. The word "pagan" is derived from the Latin "pagus," meaning "rural" and "from the countryside," which has often been used "to designate the 'other' from Christianity" (Greenwood 137). However, Greenwood argues as follows: "Rather than being based on an indigenous nature religion, many current magical practices stem from the revival of magic in the Hermeticism of the Renaissance and more recently in the nineteenth-century magical organisation, the Hermetic Order of the Golden Dawn" (137).[1] It is particularly important to note that hermetic and Golden Dawn forms of magic should be understood to have been enmeshed in Christianity, utilizing motifs, such as the Holy Spirit and the Grail, albeit in an unorthodox form, as opposed to a non-Christian "other."

Now, the Golden Dawn, and some Golden Dawn–influenced aspects of Fortune's work, particularly her use of ceremony, can be legitimately called high magic. However, this term propagates a problematic assumption of "high" magic being more valuable than "low" magic, which is often associated with witchcraft and superstition. Therefore, in this chapter, I will refer to Fortune's work as "occult." I place under the umbrella of occult the Golden Dawn, Fortune's work, some aspects of theosophy, the work of Aleister Crowley,[2] as well as contemporary groups, such as the Ordo Templi Orientis, the Astrum Argentum, the Society of the Inner Light, and modern manifestations of the Golden Dawn.

Dion Fortune

Dion Fortune was born Violet Mary Firth on December 6, 1890, in Llandudno, Wales. She attended Studley Agricultural College from 1911 until 1913, when she left after suffering a severe mental breakdown. As a result of this experience, Fortune grew interested in occultism, and after the First World War ended, she became involved with the occultist Theodor Moriarty. In 1919, she was initiated into Alpha et Omega, one of the splinter groups of the original Hermetic Order of

the Golden Dawn. In the early 1920s, Fortune established the Society of the Inner Light, originally as an outer court of the Golden Dawn, intended to attract new members to the group. In 1925, Fortune's Society purchased headquarters at 3 Queensborough Terrace in London, and Fortune began to publish occult work under the name Dion Fortune. In 1927, Fortune was expelled from Alpha et Omega. That same year, she married Dr. Penry Evans (1892–1956), who was both a practicing physician and a member of her Society.

Throughout the 1930s, Fortune saw to the development of her Society and its work. She delivered public lectures, initiated new members, and published an array of occult essays, books and novels. Of her novels, *The Goat-foot God* (1936) and *The Sea Priestess* (1938) have proven the most enduringly popular; *The Mystical Qabalah* (1935) is widely seen as one of the finest and most accessible occult works of the twentieth-century, whereas *Psychic Self-Defense* (1931) is still widely available today. During the Second World War, Fortune suspended her publishing and led her Society in an attempt to assist the war effort through group meditation. Fortune died of leukaemia on January 8, 1946 and was buried at Glastonbury. Fortune's work is hugely important because it represents the first modern, Western attempt to bring esotericism to women and the middle classes and make it available in a pragmatic, everyday context. For this alone, Fortune can rightfully be considered the grandmother of the New Age. However, her books have also been highly influential on the development of the metaphysics, symbolism, and popular imagery of several New Religious Movements. Additionally, her occult novels have proven particularly influential in the development of goddess and pagan spiritualties.

The Path of the Hearth-Fire

In the early 1920s, Fortune worked as a lay analyst at the Medico-Psychological Clinic in London. In her youth she had been involved in Christian science. In her adult life, Fortune became a member of a few different occult groups, including the Theosophical Society, the Holy Order of the Sun's Cromlech Temple, and the Golden Dawn offshoots Stella Matutina, and Alpha et Omega. She had working relationships with many of the most important occult figures of her time, including Crowley, Israel Regardie, and B.P. Wadia. Fortune, thus, came to see

many cases of women ruined by magnetic leaders with evil intentions as well as the social ostracizing of women caused by sexual scandals. It is for this reason that many of her books, including *The Demon Lover, Psychic Self-Defence,* and *The Winged Bull,* feature warnings about the dangers of powerful occult personalities. The antagonist of *The Winged Bull* is a pantomime-baddy black magician, a caricature modelled on the notorious Crowley. Many take this to suggest that Fortune disagreed with Crowley on a fundamental level, but, in fact, she was greatly indebted to his work and quoted from it heavily. What she objected to was his iconoclasm and revolutionary-ness, as well as his disregard for the ethical and social status of his followers. Fortune believed teachers of occultism and leaders of occult groups had a responsibility to their students. Magical practices had a potent effect on the mind, and many of them worked through the simulacrum of sex and charisma, meaning the risk of social scandal was great. Her time at the Medico-Psychological Clinic of London as well as her personal experiences of dangerous occultists—she had been psychologically tortured by the head teacher of Studley and involved in a scandal through Wadia's machinations—led Fortune to take social responsibility as the key principle underlying all of her work and motivating her judicious editing choices.

In chapter four of, *The Training and Work of the Initiate,* "The Path of the Hearth-fire," Fortune attempts to answer what she calls "a big question, and one that is constantly recurring ... which is the higher duty, the service of the Masters or the service of the family and home?" (43). In the following discussion Fortune presents adepthood and motherhood as two mutually exclusive paths and a choice each woman must make. This idea is illustrated in *The Sea Priestess,* in which Fortune compares the protagonist, Vivienne Le Fay, with the love interest and eventual wife of the male hero, Molly: "But then she was a sea-priestess, and Molly was a priestess of corn and hearth and garth, which is another aspect of the Great Goddess whom they both served after their different ways" (301).

It is important to recognize that this limitation was made with the desire of accessibility and social responsibility at the front of Fortune's mind. Seeing the flourishing of spiritualism, theosophy, and the Christian science movements, all of which had a large female membership, Fortune believed the time was ripe for a female-focused occultism.

However, the simple chance of being born a lower or middle-class woman in early twentieth-century England meant one was expected to undertake many hundreds or thousands more unpaid work hours—chiefly housework and childcare—over the course of one's life than a man. Even Fortune herself was not exempt from the day-to-day household chores involved in running a group home, although even the lowest-grade male members were. This meant many less hours for study, for practice, and for personal development—one of the key reasons that scholars and adepts were historically, and still to this day, mostly male. Fortune understood that having children would mean a huge increase in unpaid household labour, thus limiting the opportunity for serious spiritual practice.

It is also interesting to note, and crucial to understanding Fortune's neat division of family and faith, that Fortune believed motherhood was a spiritual choice. Although she made a nod towards the Lords of Karma, and that people inevitably end up in situations they would rather not be in, she showed little sympathy towards women who experience unplanned pregnancies. The reason for this is highly contextual: Fortune was involved Mary Stropes's clinic and the early birth control movement in Britain. Although it is not clear to what extent she was politically and socially active in this area, her female protagonists discuss birth control explicitly in *The Demon Lover, The Goat-Foot God*, and, more subtly, *The Sea Priestess* and *Moon Magic*. Fortune also referred to her own decision not to have children and her personal use of birth control in several texts. Contraception in this period was still a hugely controversial topic, connected with the development of political feminism and with female sexual liberation. Mary Stropes was one of the first women to publicly claim that women can and ought to experience sexual pleasure—a belief that underpins Le Fay's long soliloquys on personal morality in *The Sea Priestess* and *Moon Magic*. However, the key criticism levelled at this early wave of feminism is its lack of intersectionality, as it was propagated by white middle-class British women—Fortune's intended audience. In tailoring her work to open occultism to this specific group of women, she destroyed many of its intersectional applications. Although we can describe and begin to deconstruct these issues now, it is impossible to measure how powerful this exclusive narrative of motherhood as choice has been on the development of female empowerment and goddess spirituality into the New Age.

Economic Realities of the Path

When I first read Fortune's words on motherhood, before I fell pregnant, the idealist in me found them extremely problematic. Why had this great occultist, who championed the inclusion of women in the occult milieu, chosen to exclude every woman with a child? Exploring the issue in more depth, I grew to understand that this was another example of Fortune's desire to propagate a socially responsible form of occultism. She believed occultism and motherhood were mutually exclusive; if one attempted to do both, either one's occult development would fall by the wayside or one's duties as a mother would go unfulfilled. But still I felt uneasy with these comments. I was convinced that Fortune, who several times publicly defended her choice not to have children, did not understand the experience of motherhood today.

Then I had a baby.

In the contemporary West, with many fathers now sharing the load of childcare and housework, not to mention the increase in disposable income for the middle classes, it may be possible for some women today to pursue the occult path during motherhood. But Fortune's system demands an intense course of study and meditation, not to mention that if one wishes to progress through the system, regular meetings must be travelled to and attended. As a working single mother, I simply do not have the resources, those being time, energy, focus, as well as, inevitably, money. We come here to the key contradiction of occultism, which is a secret and individualistic religion that has a polemical, mutually parasitic relationship with mainstream Christianity. Occultism is a marginalized faith, but it is not a faith for the marginalised. Peter Grey cries the following in his declaration of modern witchcraft "Raw Power": "We are on the side of man, of life and of the individual. Therefore we are against religion, morality and government. Therefore our name is Lucifer. We are on the side of freedom, of love, of joy and laughter and divine drunkenness. Therefore our name is Babalon." But what of the family in this revolutionary formula? Viewing the family as defined by the monumental father god, linking thus to law and oppression, family is often neglected in witchcraft and occultism—unless through fetishizing the mother. Yet it is precisely the recognition of the power and importance of this tribal formula that is lacking in the modern occult milieu and needs to be addressed.

The need for this is most visible in the mother, for it is she who has

been left with the cruellest lot in our postnuclear-family individualism. If contemporary society is breaking apart as we fail to understand the inextricable connection between the individual and the collective, occultism seeks to free the individual from the last chains of organized religion and the restriction of society, wherein family is a microcosm of said society. The movement's roots in scientific illuminism and early psychoanalysis have led to an overwhelming emphasis on the power and agency of the individual. This individualism is a necessary part of the movement's liminal and unorganized structure. But it is also precisely why it has not, and perhaps cannot, become a mainstream form of spirituality. Occultism is structurally opposed to mundane, organized society. As such, there is no easily accessible—that is, without paying large fees and needing to travel and find childcare as the majority of occult rites are offered only adult over the age of eighteen—organized occult church structure. Tight-knit occult social groups tend to be an exception rather than a rule and too often demand sacrifices not available to parents. Yet, as Fortune herself notes, it is incredibly difficult to do magic on your own, never mind having a flourishing spiritual practice alone. It can, thus, be a difficult challenge for a mother to raise her child in such a decentralized faith.

Sexual Liberation as a New Narrative of Repression

So much pagan and goddess spirituality, as well as almost every form of occultism, emphasizes the spiritual power of sex and sexuality. This is understandable, as these traditions act as a polemic to Augustinian Christianity. These milieus tend to focus on liberation and overcoming shame towards ecstasy as a personhood and world-building experience, which has developed from what may be termed the "subjective turn" in sexuality. David McCarthy states the following: "The history of modern sex can be told as a turn inward, toward sexual subjectivity over against social constraints, toward personal fulfilment over against economic alliances and household management, toward love over against procreation. Modern sex, at its best, is an inter-subjective reality" (87).

But what of those who go searching for personal fulfilment and love and are left alone with a child in the age of the individual? These social constraints and economic alliances were not arbitrary—they were put in place to ensure mothers and children would not be abandoned.

This ideological shift can be traced to the early twentieth century and to the birth of chemical contraceptives as well as the political demand for the legitimization of female pleasure. Sex became ideologically divorced from procreation; however, this was not reflected in a true revolution at the social level. The separation of sex and procreation does not reflect the lived reality of most women in the world. This desire for sexuality to be a liberating force for women has, thus, transformed and been mutated into another repressive structure where women are now defined by their sexuality and are assessed on their agency, pleasure, and enthusiasm. The call for sexual fulfilment demands that we probe our sexuality, that we understand and explore it, and that we know our turn-ons and develop our kinks. Modesty, ignorance, as well as the desire for these quiet things to remain veiled are out of fashion. Our cultural insistence on freedom to be your sexual self demands that all selves, and all aspects of the self, be sexual. As McCarthy argues, the idea of the sexual self is something that has been constructed not by a revolutionary "other" but by the dominant social economy, which is reproduced by and maintains the inviolability or naturalness of desire in order to feed the ongoing late-capitalist social model that depends upon thoughtless, imperative desire. The focus on naturalism, and particularly the naturalness of sexuality and sexual desire, serves first to conceal the social construction and reproduction of this desire and second to position fulfilment in liminal moments of otherworldly space. Thus, when the wannabe-revolutionary witch Peter Grey locates the ultimate place of feminine/feminizing power in the bound ritual sex act, he is simply playing into this powerful sociopolitical construct. What would be truly revolutionary would be to position fulfilment in the space of hygge—in contentedness, growth, and family—the development of relationships and the ongoing, social and public role of family members.

Grey's work, particularly, *Apocalyptic Witchcraft* and *The Red Goddess*, is increasingly popular with contemporary occult practitioners. The ritual efficacy of pain, sex, and the manipulation of the body is the particular focus of his form of magic. Thus, in "Raw Power," Grey declares, "This is the first principle of witchcraft, before poppets [sic], dolls, charms, chants, potions, candles and claptrap: the raw power of female sexuality. Stripped bare, violated, hung in strappado, burned, yet woman remains miraculously unquenchable amongst the flames." This focus on sexuality comes from an admirable place—the desire to

recentralize sex in spirituality. However, it is important that we understand that the physical sexual relation, which so clearly exhibits power, is only one aspect of a much larger thing. Thus, Fortune laments:

> If I lift a corner of the Veil of the Temple and reveal the fact that sex is simply a special instance of the universal principle of polarity, the immediate assumption is that polarity and sex are synonymous terms. If I say that although sex is a part of polarity, there is a great deal of polarity that has nothing to do with sex, my explanation if ignored. (234)

To claim that witch power is sexuality is an oversimplification of the magical formula ad absurdum; sexuality is a great source and focus of power and is often one of the easiest for our modern, overly-sexualized imaginations to work with. But magic is so much more than this too, as sexuality itself is infinitely more than the moment of the coital act. We need to open our definition of sex wider. If we truly appreciate the naturalness and sanctity of sex, then we should be able to see that the sex instinct operates at every level and that the forces we call sexuality can be found in many, if not all our other relationships. We need to understand that if lust leads to sex, which leads to children, then these are all part of a greater whole.

Yvonne Aburrow has done some incredible work on inclusivity within Wicca, focusing on homosexual relationships. I think it is equally time to explore other aspects of the male-female relationship and other ways that sexual difference in its instinctual, etheric, and cosmic forms manifest and interact. What of the mother-son dyad in practical working or, indeed, the father-daughter one? If such a thought makes us uncomfortable, this suggests that we have uncovered a secretive structural assumption—that the parent-child relationship is irrevocably linked to the sexual sphere and that this assumption has not yet been integrated on a cultural level or within the practice of witchcraft.

The Path of the Cold Hearth-Stone

As noted above, Fortune wrote books for a specific audience and with a particular intention in mind. Because of this, she needed to construct a vision of family experience as something that worked within an occult/magical paradigm and that also loosely fitted with Christian

morality. She, thus, taught contentedness with one's position and to view negative experience through the lens of karma and the idea of past lives. She argued that the sacred duties of the home are steps on the Path and described how keeping house can be a praxis of personal development.

But what about the woman who cannot see these duties as sacred but only bristle at the indignity of the position? Fortune went on to discuss performing services and duties with love and beauty as well as sympathy and joy to make the humblest details more beautiful, thus transforming this home-based work into something holy. But what of those for whom this is not possible or who reject the standards of joy and beauty as being definitive? How can a feminist, or poststructuralist, use Fortune's work? In fact, occult cosmology, even Fortune's version of occultism, does have a path for the depressed, the disenfranchised, and the trapped. When Fortune discusses the "serenity of heart ... [and] faithful performance of duty" (*Training and Work* 47), what she does not articulate is that a lack of serenity is often the path to this. It is precisely tumult, temper, and failure that lead to clarity and adepthood. The articulation of this is what occultism lacks and what it needs in a liberation theology—a theology for hard times or a left-hand path of exuberant endurance, which is not privileged masochism. This is an occultism for the apocalyptic postfamily—what I would call the Path of the Cold Hearth-Stone.

Here, we must turn to examine our god forms up close for a moment. The first feminine manifestation upon the Qabalistic Tree of Life is Binah, the third Sephirah, who is also called Isis Unveiled, or the Heavenly Isis. She is the mother of gods, and it is this primal goddess power that Vivien Le Fay summons with her hymn in *The Sea Priestess*, with its refrain "Ea, Binah, Ge!" These figures are manifestations of an idea of divine femininity that Fortune believes to be both archetypal and symbolic, a genuine force that is active across the spiritual and etheric planes. With Binah, the cosmic energy crystallises into form; however, with form comes the necessary eventuality of the dissolution of form. It is for this reason that Fortune argues the following in *The Mystical Qabalah*: "Any god who has an analogy with Saturn will be referred to Binah" (90). Binah contains the ideas of life and birth as well as the necessary concurrent notions of time, finitude, and death: "Saturn-Satan is an easy transition; and so is Time-Death-Devil" (144). Saturn is traditionally portrayed as a masculine force, as indeed is the devil, which

reveals that although Fortune assigns certain Sephirah as falling under the control of masculine or feminine force, each sphere is in fact bisexual, holding within it both masculine and feminine properties. Thus, she argues that although Binah is the supernal mother, "she is also Saturn, the solidifier, who connects through his sickle with Death with his scythe, and Time with his hour-glass" (*Mystical* 83). For Fortune, Binah "is two-aspected, and these aspects are distinguished as Ama, the Dark Sterile Mother, and Alma, the Bright Fertile Mother" (46). This duality can be witnessed in "any goddess who might be termed the primordial mother" (90). It is for this reason that the feminine is mythically associated with evil and death, for "implicit in the ascetic religions such as Christianity and Buddhism is the idea that woman is the root of all evil, because she is the influence which holds men to a life of form by their desires" (144). We can, thus, begin to understand why the figure of the mother is such an ambivalent one within faith and society.

Understanding the inevitable polarity of the godhead, the whole dynamic of the goddess can be altered to the benefit of all. Polarity is the key to everything, in which movement between two poles is the energy of life itself. Understanding the light-dark duality in the divine— acknowledging contradiction and non-rationality, particularly as it is viscerally presented in the idea of the destructive mother—can provide a cosmological structure for understanding personal experience. In this, negative experience can be understood for purposes of increasing knowledge or spiritual development—or even an explicit magical aim. In particular, this focus on praxis offers a powerful counter-narrative to the happy-go-lucky trend for positive thinking and mindfulness, which is a direct descendant of the intertwining psychoanalytical and Christian science movements of the late nineteenth and early twentieth centuries found throughout so much of the New Age milieu. This perspective also addresses the general rhetoric of fulfilment and nature as nurturer that reigns in the arenas of goddess spirituality and paganism.

Recognizing the intimate, interconnecting nature of the godhead— the play of masculine and feminine, active and passive, light and dark, even within a single manifestation of the god force—can help one to find power, agency, will, as well as active, seductive possibility of fecundity, which demands the so-called active principle comes to meet it. Furthermore, this godhead, which takes it upon itself all the forgotten and forbidden gods, has an imaginative history of repressed worship—

from Dion Fortune's imaginative history of Atlantean sexual magic in *The Sea Priestess,* to Peter Grey's analysis of the Babalon myth, and the repression of the practices of an ancient goddess in *The Red Goddess.* This narrative, however questionable its accuracy may be, is an effective way to theorize and construct a personal spiritual path of solitude and pain. It offers a way to build the lack of practice and development, as well as the repression of practice and faith itself, into a greater narrative, both of the godhead and of the development of the self.

Fortune envisioned two paths for women—the Path of the Adept and the Path of the Hearth-Fire. I would, thus, add a third: the Path of the Cold Hearth-Stone, which is the path of struggle and submission as a negative ecstatic liberation theology of motherhood. This is a path in which spiritual power is not found in flourishing, frolicking, and fucking but in blood, tears, and dirty nappies. Paganism too often focuses on the light, encouraging a positive attitude and personal empowerment. But for those who are unhappy or angry, attempting to keep a positive mindset can lead to repression and denial. The mother goddess is a duality, and pagans need to remember that. Binah is Saturn/Satan, and Ceres is Persephone, who dwells in the underworld for half the year.

If we are to have a functioning vision of spiritual motherhood that is not repressive or restrictive, we must recognise duality at every level of divinity. As there is darkness, defined by a lack of light in the macrocosm, so too there is darkness, defined by a mother's struggle with negative feelings and unhappy days. For many, indeed for most, motherhood is a struggle. We must see the depression, the hard days, as every bit as holy as the good ones. Without a coherent cosmology for the hard days, people struggle to deal with pain and loss. Christianity was so effective in medieval times because it gave people a way of understanding their suffering through resignation and purpose. In its attempts to free humankind from the shackles of Christianity, paganism has too often forgotten the potent spiritual effect of the dark night of the soul. Negative experience, particularly strong physical and emotional ones and ones involving closely held taboos, can offer potent mystical experiences. Understanding the value of such experiences can lead one to develop a better appreciation, understanding, and application of the way that negative experience stimulates the development of strength, power, and the self.

Those who follow the Law of Thelema hold up the Whore of Babalon, with her chalice being the magical displaced womb, as the ultimate

abasement. In motherhood, one finds the true secret of Babalon, the unspoken fruit of her whoredom, as we are reminded that in the New Aeon, Babalon is situated in Binah, displaced from Malkuth through the birth of a child. What takes place in the experience of that holy yet mundane experience of giving birth? For the Western woman, conditioned since childhood to experience herself as a bounded and discrete individual, the act of birth destroys the foundation of identity, and the ego is rocked to the core. This is a closely guarded secret of the Hermetic mysteries: Our zealous cultural taboo about children and sexuality, as well as the continued cultural ambivalence towards the body of the mother, has allowed this archetypal structure to go unexamined by all but a few adepts.

The aim of many more advance ceremonial magical workings is the loss of ego, an essential precursor for the crossing of the abyss, and thus attaining adepthood. If but one shred of the self remains, the acolyte will be lost to the Qlipothic chasms. The experience of giving birth and early motherhood has a similar potent unselfing effect. However, because it is rarely done consciously, the mother fights to retain her ego, and much is lost to the abyss. The zombification of the mother in the first few months of new motherhood can be seen as the result of this ego destruction, as the mother struggles to reconstitute her sense of self and reconcile her understanding of individuality faced with the parasitism of the newborn's nonstop needs and demands. Eventually, the mother rebuilds herself anew, reconstructing her ego around the new knowledge and new practice that accompany motherhood. Because of the nature of motherhood, this new ego is often constructed around a resigned or devotional view, an outlook of service. This is encouraged by the Christian milieu, which puts models of servant-mothers on pedestals. However, it is also propagated in the pagan milieu, where mothers are encouraged to devote their time to giving their children magical childhoods that focus on homecooking, DIY, and homeschooling. Those who resist this model of motherhood as service are left in a constant battle to defend their individuality and selfishness. Now, I firmly believe that the greatest thing for my child's happiness is the mother's happiness. Therefore, I put my life plan and my fulfilment above all, a radical position to take even in contemporary society. However, I still face the subtle chattering in my ear, both social and archetypal, that says that a mother should sacrifice all for her child rather than tend to her own self-development

alongside care of her child. It is this duality that the Binah/Saturn godhead expresses. The birth of the child is also the beginning of learning about limitations and what is anathema to Aleister Crowley and his acolytes—restriction.

Endnotes

1. The Hermetic Order of the Golden Dawn was a magical order founded at the end of the nineteenth century by William Wynn Westcott and Samule Liddell Mathers. It was arguably the most influential of all the magical orders that flourished during the Occult Revival, and many aspects of contemporary pagan practice can be traced back to the Golden Dawn. Although the order was relatively short lived, it spawned several offshoot groups, including the Alpha et Omega and the Stella Matutina, of which Dion Fortune was a member.

2. Aleister Crowley (1875–1947) was the most famous magician of the Occult Revival. Crowley actively courted shock and horror with his work, for he believed these feelings had magical potential, and revelled in his titles self-proclaimed titles *The Great Beast 666* and *The Wickedest Man in the Word*. Crowley wrote several books about magic, including *777* and *Book 4*, and was responsible for reforming and leading the magical orders Ordo Templi Orientis and Astrum Argentum.

Works Cited

Aburrow, Yvonne. *All Acts of Love and Pleasure: Inclusive Wicca*. Avalonia Books, 2014.

Fortune, Dion. *The Demon Lover*. The Aquarian Press, 1971.

Fortune, Dion. *The Goat-foot God*. The Aquarian Press, 1971.

Fortune, Dion. *The Mystical Qabalah*. Williams and Norgate, 1935.

Fortune, Dion. *Psychic Self-Defence*. Rider, 1932.

Fortune, Dion. *The Sea Priestess*. Samuel Weiser, 1978.

Fortune, Dion. *The Training and Work of the Initiate*. The Aquarian Press, 1955.

Fortune, Dion. *The Winged Bull*. Aziloth Books, 2014.

Greenwood, Susan. "Gender and Power in Magical Practices" in *Beyond New Age*, edited by Steven Sutcliffe and Marion Bowman, Edinburgh University Press, 2000, 137-54.

Grey, Peter. *Apocalyptic Witchcraft*. Scarlet Imprint, 2013.

Grey, Peter. "Raw Power: Witchcraft, Babalon and Female Sexuality." *Scarlet Imprint*, 1 Dec. 2014, scarletimprint.com/essays/raw-power. Accessed 14 Feb. 2017.

Grey, Peter. *The Red Goddess*. Scarlet Imprint, 2004.

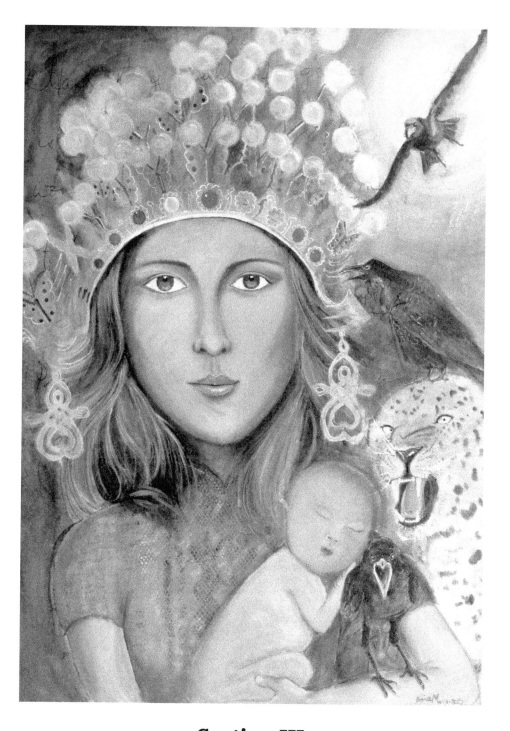

Section III

**Empowering Spirited
Mother-Daughter Lineages**

Chapter Nine

The Spiritual Dimension of Mother-Daughter Groups: Healing with Artemis, Demeter, and Persephone

Laura Zegel

In the past few years, there has been a rise of teenage "brave girls,"
who embody an independent feminine spirit and the fight for social
change. Documented in *Maiden USA: Girl Icons Come of Age*,
Kathleen Sweeney acknowledges the devastation of teen girls'
assimilation into patriarchy but argues that the brave girl archetype is
appearing and growing. Much like the Greek goddess Artemis, girls are
showing more self-confidence to pursue what they find important.
Wielding Artemis's bow and arrow in popular culture, the characters of
Katniss Everdeen in the *The Hunger Games* movie trilogy, Merida in
Disney's *Brave*, and Tris Prior in *Divergent* arrived in our Cineplexes,
offering Hollywood warrior heroines rarely seen before. A striking
number of tech-savvy Artemises prefer the weapon of *Change.org*,
which fosters activism through online petitions. *Seventeen* magazine's
including unphotoshopped images, having female debate moderators
for the 2012 United States presidential debates, and removing a
controversial ingredient from a popular sports drink are but a few
examples of real changes made by petitions written by feminist teen
girls. Malala Yousafzai uses her voice to embody this energy as she
fights to secure a girl's right to education, even after a near fatal attempt
on her life. Thus, the energy of goddess Artemis—who is emblematic

as being one-in-herself without male companionship and who is always concerned with women's needs—is challenging the dominant myth of female adolescence, that is, of Persephone in her aspect of an abducted and raped Kore.

As a local resident and mother in the American state of Maine, with an interest in empowered mothering of daughters, I discovered the Maine-based, Mother-Daughter Project, founded by Kimberly Huisman, an associate professor of sociology at the University of Maine. Huisman was motivated to create this group from her interest in public sociology. This school of thought hopes to take sociology out of the exclusive realm of academia and expose the gaps between how things are in society with and how they could be improved. Since the fall of 2012—and inspired by SuEllen Hamkins and Renee Schultz's *The Mother-Daughter Project: How Mothers and Daughters Can Band Together, Beat the Odds, and Thrive Through Adolescence*—two conferences and a film series have been held on the subject of the mother-daughter relationship. Lyn Mikel Brown, SuEllen Hamkins, and Julia Bluhm—a member of the teen activist group that challenged *Seventeen* magazine on Change.org—were inspiring guest speakers. These conferences included an opportunity for women to start mother-daughter groups in our own small Maine town, with a population of only 6,500. The response was overwhelming, with over sixty women at the initial conference starting eight to ten mother-daughter groups, which indicated a hunger among women to experience with their daughters a new, empowering kind of relationship throughout adolescence. It was a yearning to connect with the powerful Artemis energy. More women are now coming forwards to start groups as the program develops and word spreads about these projects.

Mother-daughter groups are started by women who are outraged by what the culture at large is offering their adolescent girls. These are mothers who desire change in their daughters' experiences of the borderland between the life stages of childhood to adulthood. These groups educate daughters on such topics as self-esteem, the media (including social media), substance abuse, positive body image, and healthy relationships. In their books, SuEllen Hamkins and Renee Schultz detail plans for starting and maintaining groups of mothers and daughters, developing ways to stay connected to each other, and supporting strength and resilience in girls. Groups are formed when the daughters are young so that group relationships are robust and cohesive as they reach adolescence.

Demeter and Persephone: Tend and Befriend

There is another side to starting a mother-daughter group that is not directly addressed through these mother-daughter projects—that is, the receptor in which the archetypal "sacred feminine" can be consciously created as imagined through the liminal space that exists for mothers and daughters when girls grow from childhood to adulthood. The sacred feminine is expressed in the Greek myth of Demeter and Persephone (or Kore), which tells the archetypal story of a brutal separation between mother and daughter. This separation serves the patriarchal masculine through a violent domination of the daughter. The abduction and rape of Persephone by the god Hades, followed by Demeter's rage and depression in the loss of her daughter, continues to be lived by mothers and daughters today when a girl's adolescence lacks a spiritual sense of the feminine. She may be lost to the mother, both in person and in a spiritual sense of connection to the Mother Goddess. The spiritual feminine can be expressed through an empowered relationship between mother and daughter and the development of the daughter into a woman in her own right. Ultimately, the Greek myth echoes hints of empowerment beyond patriarchy— that is, when Demeter and Persephone are reunited through Demeter's persistent search for, and recuperation of, her daughter.

The story of Demeter and Persephone forms the basis of the ancient Eleusinian Mysteries, which ritualize nature's continuous generativity as symbolized by the power of the mother-daughter relationship within our patriarchal society. Mother-daughter groups are, thus, an example of the rise of the Brave Girls Sweeney writes of, originating from their independent inner experience of the feminine. The sacredness of the mother-daughter relationship, as understood in the Eleusinian Mysteries, can be experienced amid a culture that still devalues things feminine, including having a sense of one's inner world.

Hamkins and Schultz desire to transform the experience of adolescence for mothers and daughters from what is traditionally seen as a time of separation to a time of separation that holds relatedness. They argue that adolescence is a life stage in which girls need their mothers more than ever, so why should separation even occur? Their focus on the aforementioned psychosocial issues are important as are the tools and skills for mothers that they offer. Their emphasis on monthly group meetings for mothers alone, with a second monthly meeting for mothers

and daughters, builds a supportive and united environment to get through the difficulties of life together. Shelley Taylor et al. have written that the human stress response of "fight or flight" does not apply behaviourally to women; they propose the female response is one of "tend and befriend." Tending involves nurturing to protect oneself and offspring to reduce stress and promote safety, whereas befriending is creating and maintaining social networks that aid in this process. Mother-daughter groups address this female need to tend and befriend and create relationships in which members feel supported through challenging times.

Adolescence is a time of change and is portrayed widely in developmental psychology as the time when the child leaves their family of origin and make their own way in the world as adults. Feminists in the field of psychology take issue with this model, as they argue that girls and women need both a sense of connection and individuation for healthy psychological development, yet there is little room for this attitude in traditional, patriarchal models of human developmental. Needing a sense of healthy relatedness that allows for independence is not often acknowledged by Western culture. The result is a protracted conflict between mothers and daughters aided by patriarchy, which often splits rather than unites subordinated groups (Miller).

Carol Gilligan moves away from the subordination of women's values, as she elevates relatedness and caring as equal to the more masculine value of justice. She criticizes Kohlberg's Stages of Moral Development and argues that there are essential differences in girls' development, especially involving caring for others and valuing relationships. Lyn Mikel Brown and Gilligan research how girls lose their sense of speaking authentic thoughts and feelings between the ages of eleven to twelve, preferring to conform to others' expectations in order to stay in relationships. Brown and Gilligan draw attention to girls' different developmental needs in adolescence to maintain self-esteem as well as cultural messages and social pressures that uniquely affect their development. Mother-daughter groups can address these deficits, which may lead to girls losing their sense of self. The archetype of Artemis highlights girls' and women's needs to express their individuality along with their independence through a sense of connection to other supportive women. Consciously or not, when addressing the psychosocial needs of girls and women, mother-daughter groups tap into a spiritual

dimension, creating space for the divine nature of the mother-daughter relationship as symbolized in the Eleusinian Mysteries.

Liminal Space, Sacred Space

Few authors have written about creating a sacred experience for mothers and daughters. Charlene Spretnak refers to a mother-daughter group ritual for menarche (first menstruation) that involves a spiritual component. In *Moon Mother Moon Daughter,* Janet Lucy and Terri Allison encourage mothers to create rituals for their daughters who are aged ten to thirteen. Their goal is to strengthen the relationship between mothers and daughters at this critical time when disconnection often occurs. Myths and stories from around the world are used to introduce the Goddess archetype, presenting aspects and explaining her different qualities and concepts. For example, the myth of Oya, the African goddess of female leadership, introduces girls and women to the power of confident expression verbally and through music and dance. Rituals describe how "to connect, to worship, to heal, and to celebrate," the deeper connections between mothers and daughters (Lucy and Allison 9). The importance of community is discussed by Lucy and Allison yet not in as structured and consistent a way as what Hamkins and Schultz propose. The mother-daughter relationship is affected positively when mothers make a monthly commitment to create a cohesive, regularly meeting group—a vital component that allows for a spiritual dimension to develop.

Liminal spaces, the psychological and spiritual borderlands, have the potential to be powerful places of new growth. The developmental phase of adolescence is a psychological stage that has honoured with sacred rites by many cultures for centuries. Victor Turner, a cultural anthropologist, was one of the first in Western scholarship to describe rites of passage as rituals of liminality, in which one passes from one condition of life experience into another. Anthropologist Mirces Eliade writes of the universal characteristics of girls' adolescent initiations. He states that in these rituals, the girl becomes "conscious of a transformation that comes about in a natural way [with the arrival of menarche] and to assume the mode of being that results from it, the mode of being of the adult woman" (47). A girl's initiation is individual, based on when she begins menstruating, but a pattern emerges in varied Indigenous cultures

in which initiate girls are grouped together and undergo direction by older female relatives or by senior women in the tribe (Eliade). Girls' education is directed towards the secrets of sexuality and the customs of the group, but the essence of the teachings is spiritual, as "it consists in a revelation of the sacrality of women" (Eliade 42). Initiates are told they are creators of life; it is a religious experience that Eliade states "cannot be translated into masculine terms" (45). Through the commitment and friendship of a mother-daughter group, an opportunity arises for girls to know their connection to the Goddess in all of her manifestations. Girls learn they have a special place in the cosmos that is of a spiritual nature beyond what patriarchy, mass media, and consumerism dictate.

Being a liminal being in a liminal space, such as adolescence, means spiritually transforming and breaking down old ego structures so a new vision can emerge, rooted in the initiate's inner world. A second liminal space is entered beyond being an adolescent: the individual's inner world between the unconscious and conscious minds. The initiate learns to value this as a place of healing and renewal, gaining knowledge beyond the psychosocial that cannot be studied only logically. Mother-daughter groups foster Artemis's independent energy for adolescents, which allows girls to feel that they are liminal beings in the midst of a spiritual transformation beyond their physical bodies and their social environments.

The mothers of adolescent girls have their own experience as liminal beings. Much like Demeter, their child is becoming an adult, thus transforming the mother and her relationship with her daughter. Demeter had to learn to let go of her teenaged daughter, allowing for her autonomy within their relationship. Not enough attention has been paid to the mother's own transformation as her daughter matures. Few places are available for women to feel and express how they are being transformed. Mothers acknowledging that they, too, are in a liminal space, while having a group to support them, can free what may be repressed in the unconscious. New development can occur, healing wounds experienced in their adolescence, such that they are more available to positively fuel their daughter's growth. The strong foundation of regular meetings for mothers alone allows mothers a safe haven to explore what they are experiencing with other mothers who become their committed partners on this journey of transformation.

I have never encountered a girl who did not long for a close, creative relationship with a mother who can mirror her needs during this time

of transition. I have encountered a mother who expected her daughter to hate her because as a sixteen-year-old, she had hated her own mother. Cultural stereotypes and messages portrayed in the media show mothers and daughters disconnected and in battle during adolescence (Hamkens). Mother-daughter groups create an opportunity to break these cycles, joining participants with a sense of continued, creative life symbolized by the reunion of Demeter and Persephone. A close, well-established, and regularly meeting group enhances and strengthens the experience of liminality such that the potential for true spiritual transformation is possible.

Mother-Daughter Groups: Soul Experience of Goddess

In the mother-daughter group I am involved in, we wanted to create something spiritual that was lacking in our lives, and the group seemed to be a natural place to do this. An agreement was made that this would be a long-term commitment, since our daughters were three, four, and five years old at the time. Today, we try to stay true to having fun and playing as well as creating rituals and building supportive relationships. The emerging culture of our group includes asking each other for childcare help when we need it, celebrating life transitions, such as a mother's pregnancy with a baby shower, going hiking in the woods or by the shore to connect with nature, and creating art together.

One ritual we have incorporated, is that during the month of each girl's birth, her mother tells the story of the day she was born, which brings intimacy and celebration to the group combined with a sense of women's creative mysteries in ongoing life. Artemis as the archetypal Midwife visits us then, recalling not only how Artemis' energy helped with actual childbirth, but how the birth of new psychological life is created through our group. We incorporate Hamkins and Schultz's concepts of two monthly group meetings, one for mothers and one for mothers and daughters, while also including rituals of a spiritual nature, as described by Lucy and Allison. These meetings result in deep intimacy and support between us all, which fosters a hope that our daughters will have a different knowledge and understanding of what being a women is in body and soul.

Other groups have found ways to make small gestures become meaningful rituals, such as lighting a candle while members of the group express positive hopes and wishes on a girl's birthday. This gives

daughters a soulful experience few adult women have had, especially in a group setting that includes their mother, their mother's friends, and their own friends. A group with girls who will go through menarche soon is preparing care packages for their daughters as well as educating them not only about the physical change they will experience but also about the spiritual transformations as well. Anecdotally, mothers in groups that have been meeting over a long period of time, with girls now entering adolescence, report a spontaneous and open line of communication they find striking. Bringing a group of adolescent girls and their mothers to different places, such as a forest trail or an art museum, can make space for each to express what they see or feel. These experiences can provide opportunities for them to acknowledge that they are liminal beings.

Mother-daughter groups are, thus, a means to navigate not only the threshold of adolescence but also the space between the material and archetypal worlds. Providing a sacred liminal space for freeing up what may be repressed allows for the goddess Artemis to enter and offer aid during this transition. Committed mother-daughter groups are receptors bringing to life the metaphor of the valued spiritual feminine of the Eleusinian Mysteries. When effort is made to develop and include rites and rituals, whether small or large, a true spiritual transformation can be experienced based on a girl's unique Artemis nature, which is a still rare occurrence for most modern adolescent girls. This effort has the potential to yield profound social change, empowering the next generation to confront patriarchy, as they connect with these emerging archetypes rather than the stereotypes of our day. Mothers and daughters can feel once again the spiritual symbolic nature of the mother-daughter dyad as representing the continuity of all life. The possibility exists for society to be excited about ushering in archetypes of the Goddess, which can create balance and wholeness for all.

Works Cited

Brown, Lyn Mikel, and Carol Gilligan. *Meeting at the Crossroads: Women's Psychology and Girls' Development*, Harvard University Press, 1992.

Elliade, Mircea. *Rites and Symbols of Initiation: The Mysteries of Birth and Rebirth*, Harper and Row, 1958.

Gilligan, Carol. *In a Different Voice: Psychological Theory and Women's Development*, Harvard University Press, 1982.

Hamkens, SuEllen, and Renee Schultz. *The Mother-Daughter Project: How Mothers and Daughters Can Band Together, Beat the Odds, and Thrive Through Adolescence*, Penguin Group, 2007.

Miller, Jean Baker. *Toward and New Psychology of Women*. 2nd ed. Beacon Press, 1986.

Lucy, Janet, and Terri Allison, *Moon Mother, Moon Daughter: Myths and Rituals That Celebrate a Girl's Coming-of-Age*. Fair Winds Press, 2002.

Spretnak, Charlene. *States of Grace: The Recovery of Meaning in the Postmodern Age*. Harper, 1991.

Sweeney, Kathleen. *Maiden USA: Girl Icons Come of Age*, Peter Lang, 2008.

Taylor, Shelley E., et. al. "Biobehavioral Responses to Stress in Females: Tend-and-Befriend, Not Fight-or-Flight." *Psychological Review*, vol. 107, no. 3, 2000, pp. 411-29.

Turner, Victor. *The Forest of Symbols: Aspects of Ndembu Ritual*. Cornell University Press, 1967.

My Persephone

Jennifer Lawrence

Today my daughter came with me into the garden,
Following in the footsteps of your own child.
She knelt with me to dig holes for the peppers and the tomatoes,
Packed moist earth around the roots of the cauliflower and broccoli.

I taught her about throwing away stones that would cramp the growing
potatoes,
About compost and how even things we might consider garbage
Can nourish a tender, growing thing,
And about destroying parasites before they have a chance
To hurt the vulnerable babies that we work so hard to raise.

I told her about the three things that every plant needs to thrive:
Warm sunlight on its face to urge it towards the sky,
Sweet earth cradling its core to feed it day by day,
And water poured gently all around so it might not fade and wither.

She listened soberly, face tilted towards the green shoots
That would feed us in the months to come, understanding a little
What it means to till the earth, to protect defenseless young living
things

That cannot defend themselves, and so
In a way, she understands what it is to be a mother.

O Demeter, hear my prayer, as my daughter becomes like yours,
Sitting at my side when I kneel in supplication to you
Among the basil and the sage, the asparagus and the corn:
Watch over her with the same dear love you bore your own Persephone,
And keep her safe until it is her time
To move on and create her own garden.

The Thread.
From Mother to Daughter to Grandmother: Mothers Talk to Their Daughters, from Mythical Times to the Birth of History

Arabella von Arx

The lives of a few lucky, or unlucky, women have been recorded in history, such as Bodicea, Cleopatra, Joan of Arc, Queen Victoria, Indira Gandhi. The narrative of the women who, while anonymous, left their mark on the world by generating a continuous thread of daughters is told in myths and fairytales but has been spurned by history. I sat at my desk to scribe this imaginary log in a historical context. Mother after daughter after mother, I collected the cares and sufferings and toils and brief moments of joy of the women to whom we owe our existence. Every mother seems as mighty as a goddess to her little girl. And isn't she? Without the life-giving, nourishing, and healing powers of women, we would not be born; humanity would not endure. We owe our existence to lineages of unknown women, who beat the odds of natural or violent extinction.

The daily work of women have usually involved wool making, from raising sheep to embroidering elaborate patterns. I contributed to this modest toil by weaving a string of women from mythical times to the

birth of modern history. As a visual complement, my drawings are sketched with one stroke as if just one thread had been used. These thread drawings are inspired by women or by works by women from wide-ranging periods and origins as the mother-daughter experience transcends time and geography boundaries.

First Thread

Figure 1. One Thread

I never knew my mother. I am a foundling. Now you know, there is nothing else to say.

Second Thread

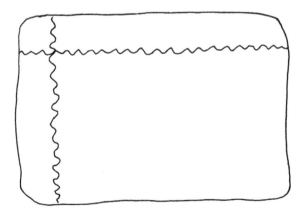

Figure 2. Two Threads

You are my daughter and the granddaughter of my mother. When you have a daughter, she will be my granddaughter, and I will be her grandmother. Do you understand? As we wrap the wool to make a skein, the thread runs far at first, then joins the others, to run away again.

My mother said: "I never knew my mother." All children have known their mothers from the inside, and when they come out, the attachment that has grown between the mother and the child never gets forgotten. My mother denied this bond, as if it had never existed, as if she were born from a stone on the road. She did not know tenderness. I wished I had had a mother like the others, who cared for me and who caressed me.

The villagers whispered crude tales when they thought we couldn't hear them. Beings half human half animal live in the forest and come to the villages at night, they said. The inside of their mouths is bright pink, and their eyelashes are as long as a cat's whiskers. They slide under the door or down the chimney to take advantage of young girls asleep in their beds.

The children thus begotten are different, even if it does not show at first. My mother feared nothing, not even the wolves. When they scratched at the walls at night, when they howled up to the sky, she went out just as usual, chopped wood, fetched water. They would not touch her, and no one knew what happened between them. Better not to tell that my mother was a foundling. Perhaps, eventually, it will be forgotten, as years go by, as kingdoms come and go, temples turn to dust, and poems are lost to memory.

Third Thread

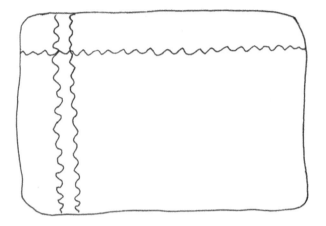

Figure 3. Three Threads

At least I have you, golden flower of my life. When you run to me, the prettiness of the child in your face and your small, lean body softens my eyes. I bend to kiss your hair and smell the fragrance that rises all the way from the ground through your veins. You make me forget the insults people shouted at me, the children who threw chestnut husks when I was small, and the men who tried to take advantage of me. I would not find a husband anyway, they said. I did marry, you see, even if your father is not skillful. For you, we will find a good husband, young and handsome and willing. I will pass on to you all that my mother taught me until I do not remember because I will have given you everything, as you gave me everything. We will ask the neighbour who knows embroidery to show you, and also the basket weaver and the pot maker, until all these accomplishments hang from your wedding garland. I will feed you herbs that give health from the strength of the soil, honey from the sky for your beauty to soar like the birds, salt to grant you the fertility of the seas, and fatty cuts of meat to keep your love for me as vigorous as fire. We will send you far to a seashore village where they do not know us. We will plump up your dowry with our best blankets and pots and tools and with the four silver coins that I hide in the bread hutch.

Fourth Thread

Figure 4. By the Seashore, *after Belkis Akyon*

I was alone on the sand, like a fish left behind by a wave. I clasped against my chest the silver coins rolled in a cloth, which my mother had given me, her only treasure, and some embroidered linen. The village in the distance looked forbidding. I felt so forsaken I sat down and cried. A man was approaching the shore in his fishing boat. I didn't see him right away, as my eyes were filled with tears. When he beached his boat and dragged it up, I noticed the strength in his arms and back. His bare chest glistened with sweat. Still, I couldn't make out his face since the sun lit him from behind. I got up. Silvery fish gleamed at his feet, so numerous they seemed multiplied by a miracle. The eyes of the man also had silver reflections. An odd gentleness softened his face. He was busy gathering his catch when at last he noticed me. He dropped his net and looked at me for a long time, as if I were a bountiful tree of an unknown type. When he finally spoke, it was with the strange accent that I would soon know so well: "Are you hungry?"

He lit a fire on the beach and grilled a dozen small fish. We shared the food in silence. It was good and copious. I learned later that fishing comes with little effort, whereas in the fields, we had to toil hard to eke a little grain. Fishermen are kinder to us women than farmers: They don't crave to own land.

The man on the beach became my husband, your father. I became his wife. I was lucky. Even if his back is not quite straight, he can fish. He beats me sparingly, and he seeds my flesh every third summer.

Fifth Thread

Figure 5. Ariadne by the Sea, *after Evelyn de Morgan*

We fled to the ravines and the hills. They stole everything, the honey, the wine, the salted fish, the lard. The boats and the nets, of no use to them, were left behind. Yet we did not starve. Come drought or hail or floods, we always have the fish. Our men go fishing, never the women. Men must conquer the sea and snatch the life that flutters in the darkness of her belly. The sea rages in storms. She calms down, and she gives sometimes, abundantly. To us women, she spreads pleasure through our organs, its waves engorging their shores. The children delivered later are much hardier than those born of violence. She likes to follow the moon, which tosses us around every four weeks. We don't always know it, but tides sway twice a day the depths of our bodies. There float our little ones before they emerge, when they are still fish. Pleasure and children, for which men envy us, are pearls embedded in our bodies by the sea. In exchange, we must not fish. You knew that already, didn't you? We can collect mussels and shrimps if the water does not rise above our knees.

Because we belong to the sea, our nets catch better. When men make nets, as they do in some regions according to travellers, the fish escape

between the meshes. You thought you did not know, but once you started, it came to you naturally. Men strive, but we can. Losing blood signals our ability to give life. For men, it means death. They can never take enough, whereas we receive the gifts of life and nurture by birthright. For this, they will always make us suffer.

Sixth Thread

Figure 6. Vanity, *after Rachel Ruysch*

All the other children got sick, except for me. Some died; those who survived had holes in their skin as big as navels. My mother died too, shriveled and spotted and shrunken. I was so young; my first baby teeth had hardly fallen out. Secretly, I envied the other children who, thanks to their nasty scars, had kept their mothers. I wish my mother, not I, had worn the protective bracelet. Why live if she had to die?

And then we had war, or maybe it was at the same time. I'm not sure. One day soldiers arrived all dressed in metal. The daily life we had always known was ripped to pieces. Instead of goats' bones and skulls and teeth, humans insides were strewn on the road. Blood flowed in syrupy skeins. The air got thick from the smoke of burning houses, and the fields were trampled to mulch. I would have given anything to get back the tidy world of my childhood, but kings in their distant cities had torn it apart. The war left as it had come. We didn't know why. At your age, I had neither mother nor father. My brothers never returned. I inherited the olive orchard that should have gone to them. It will make for a rich

dowry, when your father goes looking for your husband. Hopefully, he will be kind and skilled and will not beat you often. If he does not carry you too far away, I can visit you and comfort you in your sufferings.

Seventh Thread

Figure 7. Life and Death, *after African American quilt*

See how this hair in the bracelet is blond, and this one is thick and black? We will add one of your hairs today, which may not be cut but must be ripped off your head. The threads, too, vary in hue and shape. This one, loose and thick, was spun by a lazy young woman, long dead now. I would guess an anxious mother twisted this tight, thick strand. A little of our blood and a little of our work get trapped in the bracelet to insure our lineage survives. When you are alive, you protect your children with your care. And when you are no longer of this world, when your body has long decayed in the ground, when your skull and your bones have turned to powder, you will continue to watch over your offspring, child after child after child, farther than you and I can see, beyond kingdoms and poems.

Eighth Thread

Figure 8. Laughing Woman, *after Dona Ann McAdams's Photo of Performer Karen Finley*

My life is easier, but I do not know how to laugh like my mother. It filled the whole house. Nothing else mattered, the milk that spilled, the winter that came too soon, the crumbling roof. Everyone heard it; it was her response to the world. There was no point in asking what caused my mother's laughter. She laughed because she knew how hard life is, especially for women.

Her laughter smelled like the flowers she planted on either side of the door, like the sesame cakes she baked, like her skin, soft and warm, when she cuddled us. You do not remember, but she held you when you were born. I wish she had lived longer, to see you grow. I would have watched her love you as I love you and you love her as I loved her. You enjoy singing. She did, too. She remembered right away the poems the travelling beggars sang, never to forget. Singing passes the time, when we clean wool. Tomorrow, when it is dry, we will spin the wool. I enjoy spinning. You will, too.

My mother said, if I sit down, who knows if I will get up again. She washed and clipped, she carried, she scratched, and she served my father. When it was hot, she would teach us to weave a fan from the leaves of the fig tree. In winter, she blew on our fingers and rubbed our feet to loosen the blood. She read signs in the entrails of fish and in the stars because she feared only one thing: war. She never belonged to us or to her man who beat her all the more. I would have liked to own a small piece, but no one ever did. Nobody was ever able to say "She is mine.'

Ninth Thread

Figure 9. Goddess, *after A Photo of Lady Gaga*

I begged Mother to take me with her, and for the first time, she agreed. I was eight. I expected the mountain village to have pink stone houses and gardens fragrant with hawthorn, as in the bard's poems. As I trotted next to my mother, I was dismayed to find the village streets reeked. The houses were made of rough stones and trunks fouled by smoke. Old men, sitting in front of the doorways, sucked onions with their toothless gums, the juice running down their smocks. All day and even at night, adults and boys were away in the fields, while filthy little girls ran around the streets with their goats. When they laughed, all their teeth showed, but they had no shame; their hair was unkempt, and their noses were dirty. They surrounded me, touched my clothes, smelled my hair. Terrified, I ran up to my mother for protection.

She started taking care of my grandfather, who had injured himself with an axe. Lying on his pallet, with the wound in his side oozing a greenish liquid, he screamed: "Go away, demons, go away. I hate you, and your bat wings, and long eyelashes, and pink gums. Let me go! You are so malicious. You flew me over to the woods where you dropped me right over a sharp trunk. Ayee, it went through my chest, help, help, chase the demons away!"

My mother and my aunt applied poultice of plants and salts and ground roots, but he only shouted louder, and the pus got thicker. They never left his side nor did I, fascinated by the unfamiliar situation. When they shooed me away, I played outside briefly to please them, but came back as soon as I could to my corner. The old man didn't open his eyes anymore, nor did he eat or drink, yet he still cried loud. On the eighth day, my aunt nailed him to the bed by the shoulders, and while his eyes tried to jump out of his head, my mother made him drink a viscous potion. I didn't recognize her; her face was rigid as iron. My grandfather went quiet, his skin changed colour, and a few hours later, he was dead. My mother, who had always seemed so tame, glowed like the goddess of the temple, protective and terrifying all at once.

Tenth Thread

Figure 10. Amazon, *after Antique Bas Relief*

"My daughter my little girl
Sleep high, sleep to the right
Sleep down, sleep to the left
Shhh, shhh,
I will protect you from all
I will protect you
From the spells of the demons,
From knives lost,
From avarice,
Starvation,
Satyrs and barbarians,
Fervour,
Fevers,
Pustules.
Shhh, shhh,
From lice and fleas,
From frostbite,
Blindness,
Slavery,
Floods,
Temples that collapse,
From men
Who come and plunder
Who beat and rape and torture and kill,
Do not be afraid
In my arms, tenderly,
High to the right
Low to the left,
The armour of my love
All dangers will stop.
Nothing will happen to you
Shhh, shhh,
Nothing will happen to you
Never ever
Nothing bad ever."

Eleventh Thread

Figure 11. Nursing Woman, *after Antique Statue*

My sister was still a child when she played at throwing stones in a pond. Harmful vapours from the water spoiled her eyes because she was not wearing the bracelet. Promise me you will not throw rocks in ponds and that you will always do what should be done and never what should not. We must treat my sister kindly, as she cannot marry, or have children, and will always live with us.

When you were born, my sister taught me how to nurse. If the baby does not feed well, it will not survive. See how I put the nipple deep in your brother's mouth? My sister knew. She showed me with her hands, when she had never nursed a baby or had seen one being nursed.

We were raised by our father's mother, a bitter woman who resented us as she resented everything. In her harsh accent, she told of barbarians from the north who abducted young girls, of foxes with pointy teeth that bit at stomachs, and other stories even more horrible that I'd rather not tell you.

At night, I always slipped in my sister's arms for comfort. She stroked my hair and whispered in my ear: "Do you want to hear a story?"

"Yes, tell me about our mother."

"She was the sweetest, the most gifted, the most beautiful of all the village's women."

I envied my sister for having known our mother, before she died giving me life.

"Tell me, tell me more," I pleaded.

"She covered my hands with kisses when I pricked myself on the distaff. If I didn't want to eat my gruel, she gave me the sweetest sesame cakes instead. Her songs enchanted all who heard them. She had learned them from a bird that had tumbled into the yard's font, I remember, and broken its wing. She nursed it back to health until it was ready to flow off. She tied a yellow ribbon around its throat to remember her by."

"How old were you then?"

My sister sees everything from the inside, but our view is obscured by things and time.

"Tell me about the wedding."

"It was the most beautiful celebration we had ever seen in the village. Musicians played, dancers circled around the groom and bride, honey ran down mountains of sweets."

I shook my hands before my sister's eyes, making the light of our oil lamp flicker, but, oblivious, she went on caressing my face.

"And before?"

"When she was a little girl, Mama's top would win every time! While her siblings' tops had long tumbled, hers would keep on spinning and spinning and spinning."

"What about before Mama?"

"It was sad then. There was war and famine, and parents abandoned their babies on the side of the road. Let me tell you now about the future."

"Yes, I want to hear!"

"You will grow wise and beautiful like Mama; sickness and death will spare you. Childbirth will be easy, and you will have a daughter that will marry into the island's best family."

"What about your future?"

"Mine stopped the day I threw stones in the water. But you will have children who will have children and will secure your lineage forever."

Twelve Thread

Figure 12. Woman, *after a Photo of Camille Claudel*

She excelled at everything, whether embroidering, spinning, weaving, or mixing perfumes. She was beautiful, tall, always elegant. From her hands, only exquisite works came forth. We were slow and clumsy, except for my older sister who learned fast and showed great aptitude. My mother only had patience for her. I knew I would never rise to her expectations. When she was particularly exasperated, she would drop everything and leave. I would look for her in her room and find her in bed, staring at the ceiling. Sometimes she cried, and I never knew why. It hurt. She let me lie next to her and dry her face with her handkerchief. She held me tight and whispered in my ears. She told me the city was larger than I could imagine and that other lands and other seas lay beyond its walls. I cuddled against her slender body.

"Stop it. I do not believe you. I love our house. Your room is so beautiful. Will it be mine one day? Or will it pass to my sister because she has won your delight?"

"I hate this room."

"Mama, what saddens you so?"

"Shhh. It's nothing. Soon, we will live in another house. You'll see."

"Are you crying because we have to leave?"

"No, it doesn't matter. The house will be more beautiful, larger too. We will give this house to your cousin as a dowry, since her brothers have been supporting Papa at the assembly."

"I do not want to leave. I wish you liked our house and that you liked us too."

"An important man like your father needs a banquet room for entertaining."

"Will I go to the banquets?"

"Only men attend."

"What do they do?"

"You're too curious. Do not be curious. It is our role as women not to know certain things of men and of the city and the world."

She took a bowl from her table and offered me sesame seed biscuits she had baked herself. They were so sweet. I wish mine were as good.

"They talk about politics and geography and history," she said.

"Tell me history, Mama, the whole history."

"I do not know.'

"How do you know that they speak of history?"

"I asked a servant."

"If you asked, you wanted to know."

She sat up on her bed, wiping her tears.

"Enough now. Be docile. I beg you. Don't make my life even harder to bear."

"Do they tell of monsters and gods and princes, like the bard?"

"No. You do not understand. You're too small. They debate about events, some ancient, some recent. They discuss kings and wars, temples and monuments, laws and poems. Men are powerful and women stay home. We do not know. Perhaps an enemy faction will gain influence, and we will lose all our belongings, live in rags, and beg for our food. Maybe there will be an attack of barbarians, a war, or a famine. From inside our homes, we cannot change it. But, day after day, you can enrich the weave of your life when you add an unexpected pattern to your daily chores, when you sing to a restless child in the middle of the night or you bake a sesame cake for the loss of a tooth."

Thirteenth Thread

Figure 13. Couple, *after Antique Greek Vase*

My mother knew many languages. She read treaties, she wrote. She got in a rage at any disturbances when she worked. She stamped her foot and broke vases. My aunt, who lived with us after the death of Papa, rebuked her: "In our city, you could never have behaved in such a fashion. It's not becoming. In addition, you do not sleep enough. You're going to grow old too fast and will lose all chances to remarry." But Mama did not care. Every evening, her lantern burned late into the night. If I woke up, I saw her bent over a book with her magnifying glass. I approached, but she did not hear me until I touched her shoulder. She smiled and took me on her knees. I cuddled against her chest, inhaling the hibiscus smell in her neck. She scolded: "What are you doing here, instead of sleeping?"

"You're not in bed either! How did you become so learned, Mama?"

"I stole, I spied, I lied. It's so far now. I thought one day all knowledge would be mine thanks to hard work and a good library. Now, I know better."

"Tell me a story, a beautiful story about the world."

"A story! At this time?"

"Yes! About the mother whose daughter was taken from her, and the

land went barren until they were reunited."

Mama opened a box of precious hard wood and picked a scroll.

"Here. Read."

She pointed to my favourite part of the story. I deciphered as best I could: "She inflicted a terrible year, bitter and cruel. The Earth did not grow any seed. Many an ox dragged their curved ploughs through the fields, all in vain. Many a grain of white barley fell to the earth, all for nothing."

"It's too difficult, Mama. You read it."

"You're doing well. What is the next line?"

"Then, as now, she could have destroyed the entire speaking race of humans."

I soon fell asleep, my head nestled in my mother's shoulder. All night, I dreamed of goddesses and golden chariots, of crocus, iris and hyacinth. In the morning, I woke up to find I was back in my bed, as if by magic.

Works Cited

Anonymous, *Homeric Hymn to Demeter*, Verses 305-9, p. 17.

Chapter Twelve

Goddess Is Mother Love

Nané Jordan and Chandra Alexandre

We are the wise ones, healers, shamans, priestesses, witches,
and midwives,
We are the mothers—we tend, care, grow and guard—
leading with love,
We listen to the ancestors and to those yet to be born,
across time and space,
We are the old ones, the new ones—co-creators,
birth-givers, life-makers,
We are the ones we have been waiting for,
We are mother love.

—Nané Jordan

We, Nané and Chandra, offer our voices as weavers of our mother stories from the forefronts of Goddess-centred, postpatriarchal home spaces. We tell our stories through the practice of "*métissage*," an arts-based, life-writing inquiry practice that braids voices of more then one author into a single creative nonfiction text (Hasebe-Ludt et al.). Our weaving offers readers a storied back-and-forth dialogue on themes of our mothering lives in concert with our dedication to Goddess spirituality in ways that are personally meaningful to each of us.

Nané is a birthkeeper, a Goddess scholar, an artist, a community worker, and a mother. She has been involved in mother-centred birth work and feminist research for over thirty years. Nané lives, writes, and

creates with others across the fields of women's spirituality, birth studies, holistic education, and the arts. Her life pathway with Goddess is deeply interwoven with her studies and practices of traditional and homebirth midwifery, which serves to support and empower mothers' birth experiences and reawaken the embodied powers of birth. In giving birth and becoming a mother herself, mothering became an unexpected pathway of who and what Nané needed to be and do—it was a healing journey of self- and homemaking.

Chandra has been a spiritual leader and community change maker for over twenty years in the San Francisco Bay Area. Her dedication to the divine female emerged on her own healing journey, and she became an initiate and later a lineage holder on the path of Śakta Tantra after first travelling to India in 1998. Today, the nonprofit she founded facilitates personal transformation in service to social justice through a ritual and volunteer-run community. By sharing some of her journey as a mother, teacher, and leader, Chandra elucidates concepts from the philosophical and mythical to the deeply personal, expanding notions of the female and feminine relevant for women today.

Nané—I believe that empowered, postpatriarchal mothers are social leaders for themselves, their children, and generations to come. Nurturing Goddess-centred, feminist spirituality in family life can heal familial, social, and bodily harms through creating egalitarian, loving family relationships that value women, girls, and mothers—those living and divine. Through my years of work in lay midwifery activism, and then as a women's spirituality scholar, Goddess-centred ways of life have nurtured my daily spiritual practice of mothering two vibrant daughters.

As a young woman, I followed my inner calling towards grassroots, homebirth midwifery studies. I had not yet understood how deeply this work would affect the daily life of raising my own family and my intentions for healing and love in family life. By the early 2000s, I had met my husband and given birth to our two daughters. I was immersed in alternate cultures of feminist practice that counter the patriarchal medical model and instead honour women's bodily wisdom, holistic mother-centred birth practices, woman-to-woman support, mother-baby bonding, extended breastfeeding, as well as attachment and attuned parenting. In this, we developed practical communities of birthing and postpartum support. Midwifery was the genesis of my awakening to the hidden powers of women, Goddesses, as well as feminist community

building and healing. Goddesses, like birth power, have been hidden, ignored, or coopted through patriarchal culture and male God concepts, which have sought to control women's bodies and lives. Yet the powers of women giving birth beautifully and fiercely express the divine life force as Goddess herself. It took me many years to articulate this—that is, to link the reclaiming of mothers' birth powers with female spiritual authority in a Goddess-centred, Earth-loving, and mother-based consciousness.

Chandra—Today's news, in the United States or India, is filled with misogyny, specifically a hatred, if we are to name one root, of our woman power and a hatred, if we are to name another, of our mystery. We are inherently untameable because the fundamental mystery of life that lies within women cannot be reached, obtained, controlled (although they try through the structures and systems of patriarchy), or taken from us.

In India, while male supremacy looms larger than life, there is another reality, a minority reality—one that is nonetheless powerful for its gifts, knowledge, passion, beauty, and deepest honoring of life itself, even when that honouring looks unexpectedly like destruction, dissolution, chaos, and death. I speak of the ancient philosophical, spiritual, devotional, and lived realities experienced on the path of Śakta Tantra. This living, unbroken tradition of veneration of the divine female has a profound openness to complex beliefs yet upholds Goddess as fundamental, primordial, and all pervading—she who is both creatrix and void, darkness and light. She exists in stark contrast to the patriarchal denial of śakti, which is the ever-present, life-giving, motivating, activating, and spiraling energy that inhabits us all across differences of gender, race, religion, ethnicity, sexual orientation, ability, age, and other distinctions.

Particularly understood as potent in women, women's blood, birthing, and the female cycles of sex, death, birth, and rebirth, śakti is an antidote to myriad oppressions. It is a force that arises as we are called to heal, to act, and to be in a raw and ready stance of permeating respect and dignity for, with, and as the underbelly of creation in this unfair and unjust life, where all things are possible if we agree to see one another's greatness.

Nané—My vocational pursuit of holistic, love-centred midwifery in the Canadian pre-regulation days of the 1990s was twinned with my desire to create a family of my own. Becoming a mother became an unexpected feature of who I am and who I actually needed to be. I say

unexpected, as being a mother was not exactly what I thought I would or should be doing when I grew up. Growing up as a child of divorced baby-boomer parents with feminist values, I knew I needed to have a job or profession to thrive. But I had little in the way of revisioning motherhood alongside this. I had gained educational privileges from my mother's generation of feminists to study and work in my own right, yet I also yearned to create and sustain a family of my own.

As a young birth worker, I attended and led various forms of women's spirituality and Goddess circles. We learned from women's spirituality books of the times and from one another, calling in the four directions, creating blessings, singing songs, and sharing about our lives through storytelling and honouring our lives as women. We sang, drummed, cried, laughed, danced, and heard one another to speech. I sought out workshops with mentors of the Goddess movement—those beloved teacher-priestesses who travelled the country in the 1980s and 1990s, including Vicki Noble and Starhawk. I was becoming attuned, as I had been since childhood to the Earth as Mother. I spent time in Her wild places, the mountains and forests, feeling into the elements and subtle forces of nature as interconnected and healing. As life went on, both midwifery and spiritually gathering with other women helped me to see how I wanted to mother a family of my own, while continuing my intellectual and spiritual development as a female human being.

After the birth of my second daughter, my chosen midwife was jailed after a court case initiated by the British Columbia College of Midwives (see: Aearts; Ogilvie; Tritten and Lemay). Disheartened by the intensity of midwifery politics, I was deeply called to pursue a Master of Arts degree in women's spiritualty in San Francisco—a vital local of women's spirituality community, with active mentors and leaders. In San Francisco, Goddess feminism and women's spirituality flowered and bloomed, growing from social justice activism and the scholarship of the American women's movement. Within a powerful women-, Goddess-, and spirituality-centred curriculum, we studied feminist scholarship while creating our own rituals, art, and research projects based on the needs and impulses of our own lives and voices. Thus, as a young woman becoming both a mother and scholar, I was blessed to study with many foremothers of women's and Goddess spirituality, such as Vicki Noble, Chief Luisah Teish, Z. Budapest, Judy Grahn, Dianne Jenett, Elinor Gadon, and more. I needed their wise mentorship as I journeyed through

this life-affirming, holistic, and sacred form of university studies, which valued all aspects of life and research as lived experience. I met mentors, friends, and colleagues who still nourish me to this day.

Chandra—At the heart of Śakta Tantra is a commitment to the divine as both immanent and transcendent, to the interplay of duality and oneness, to the untameable power of nature, and to the liberating potentials of our own trauma. The path invites us deeper into the cosmos, to heed the call of our ancestors, and to make offerings of our tears, sweat, spirits, and menstrual blood, leading to a palpable connection to life. This became real on my healing journey from anorexia nervosa, when I chose life instead of death in my twenties and suffered on the difficult road to healing for decades. It also became real when I birthed my daughter at home, becoming a mother well over forty in a world that told me being a mother, a non-profit executive, and a spiritual leader was impossible. Whether in San Francisco or at the Bay of Bengal, people felt comfortable telling me I couldn't have it all.

But the path has us light fires of remembrance and promise, and it invites awareness of the power we have to claim everything and nothing as our own. The path says we are divine in our skin, mortal in our prayers and disbelief, and completely perfect as we fall apart. It prefers wild abandon to right and wrong and offers us a ride with suffering along with an unshakable yearning for the unique and heartfelt pull from the future of those who will inherit our choices. It disavows sin, eats taboo for breakfast, and makes our overinflated egos into a tasty dessert. For me, it was the beginning of my unravelling in service to my truth and the seed that planted my daughter's inheritance as a woman freed from the bondage of her mother's and grandmother's silence and pain.

Nané—As I get older, I understand more and more how recouping relational love and recreating home have been at the heart of my own healing, living, and scholarly path. Mothering is a huge challenge in how to raise our children with enough resources, care, and love in these still patriarchal times. Motherhood and motherwork have been decentred and devalued; they have been coopted through years of patriarchal socialization and control of women's bodies and minds. When my children were young, and even though I am well-partnered in childrearing with my coparenting husband, I felt pulled between the demands of motherwork and other work. I had to find my own way into creating a nurturing family life while pursuing my vocation and spiritual callings

as well as making ends meet. In my family lineage, my grandmothers were homemakers who served their husbands and cared for their families; they were of the prefeminist generation, which didn't have the educational and work opportunities that I do. In contrast, my baby-boomer mother was able to study art and left her marriage to my father when I was young. Yet she was unhappy with the job she ended up in and lived with unaddressed mental health issues and explosive rage that affected me deeply as her daughter.

Through the challenges and gifts I received from this familial lineage, I started a family of my own, and made my own brave step when I chose to study women's spirituality in San Francisco. This degree didn't make much sense in the workaday world; people asked me what I was doing and what exactly is women's spirituality anyway. Yet this path became a touchstone for developing my own values and sense of being and for becoming a thriving mother and scholar. I began to write about birth politics, liberating female embodiment, midwifery, Mother Earth healing and care, blood mysteries, and mothering—birthing my own voice within a community of sister scholars. Even so, I struggled as a new mother to create the life and love I wanted for my family. I learned I had to attend to my childhood experiences and my own mother wound by caring for and healing myself with assistance and support from others. Over and over, I recentred myself in the life-giving relationships I cocreated with others—with my husband, children, family, friends, colleagues, community, trees, nature, and Mother Earth.

I opened in devotion towards Mother Goddesses, such as Mary, Tara, and Devi, as I leaned into and felt their luminous threads. In living a love-centred ethics of feminism that honours Goddesses, divine Mothers, and Mother Earth, all while becoming a mother myself, I found a reparative spiritual pathway of life—in both struggles and joy. Being in Goddess-centred ceremony with other women and living on Mother Earth with open awareness and gratitude have affirmed my sense of being in love with life and my natural joy and dignity as a human being, woman, and mother.

Chandra—As a mother living my connection to Goddess, I have fought, been broken open, been taken down, been revealed, and been healed because patriarchy has gifted me with insight into my own nature. The tantrics say that by which one falls is also that by which one rises. Others say cursed is the wine and the blood of those who cycle with the

moon. Banished are widows and the witches who see and seek the truth, they say. Blessed are the meek, the poor, and the destitute, they say.

My story is all too common in its unfolding, and I recall that mystics across time have spoken to the human experience as a breaking open into love if we are dedicated. Dedication on the path of Goddess to me means embracing Her qualities as drivers for right thought, speech, and action. These qualities exist in relationship; they exist in cycles, in the chthonic, as well as in the antinomian and subaltern, and in the embodied reality of our beingness. Through these we, find Her, we find ourselves, and we offer hope to the world.

Nané—Thus, mothering is valuable work, central to the regeneration of all lives. Nurturing and love are gifts to have and to give. I give myself to this Goddess- and mother-centred life. In it all, my health and lifepath have carried me through many amazing journeys, including to San Francisco and to later pursuing doctoral research into women's spirituality and transformative learning. Yet as I completed my PhD, something shifted. I could no longer do it all. I lived through excruciating daily limits of fatigue, with physical symptoms and psychic pain that stopped me in my tracks. All my years of Goddess spirituality came to bear in this new shape of my life through illness. I was made acutely aware of difficult inner and outer pressures. My body was exhausted from the years' long haul of doctoral studies and familial pressures. Working in the academy in alternate ways takes a toll, even if based on inspiration and passion for the work. I had been mindful of how my yearning for a life-rooted spirituality of the Mother is linked to my need for mother healing, based on experiences of my motherline, and for shifting the patriarchal culture at large. I had to further face my own experiences of trauma. A growing thread of gentleness, that I struggled to nurture, was how Mother Goddess came to me. Inner kindness became a practice I need to this day. Holding loving, gentle threads, alongside the family and home I co create, is my solace, and the gratitude for my loved ones is forever expanding.

Chandra—Claiming voice and body and the whole of this moment (and the whole of the next), I stand in the reality of my incarnation as a woman, connected to the root of my longing, open to that which moves above and below as well as through and within me. I stand lacking a divine agenda but inspired by divine grace to act and be more of what it takes to titrate in enough śakti with my co-conspirators to help lick the

wounds clean. We must own the dark and the light, it says on the path, to become immortal. Motherhood, the illuminated tantrics dare say, can initiate one into stirrings of immortality. It offers freedom from the veils and encumbrances that we carry by virtue of our birthing, with its blood and bond of flesh opening us to terror and the healing balm of love at the same time.

Nané—Becoming a mother and creating a safe and loving home of my own have been the central reparative practice of my life. This is homemaking in a procreative and social sense, creating an inspired and inspirited life for oneself and others from the circumstances one is given. Goddess spirituality has been a vital source of remothering in my life, through healing circles of sisterhood, immersion in life-giving scholarship, and connections with Mother Earth and divine Mothers. There is a larger story I'd like to tell about Goddess spirituality, feminism, and healing as well as about reclaiming the sacred work of mothering and homemaking through nurturing oneself and others but doing so in ways that do not defeat the self-development and autonomy of women as mothers. Dealing with intergenerational trauma, as well as gender, race, and class barriers, mothers struggle to find what they need to care well for themselves and their children. Goddess spirituality has been about transforming and healing my own and other women's lives, overcoming difficulties to become ourselves as fully as we can in the world—in our birthing, living, working, and striving to care for others in our partnerships and communities. In healing and loving ourselves, we heal past generations as well as those to come. Goddess spirituality is my way of living from the knowledge that there is no division between the sacred and the profane. Goddess is alive in daily life as well as in the ways I live with and love others and myself—Goddess is Mother Love.

Works Cited

Aerts, Louise. *Supreme Court Judge Sentences Illegal Practitioner Gloria Lemay to Five Months in Jail.* News Release, College of Midwives of British Columbia, 2 Aug. 2002, www.cmbc.bc.ca/wp-content/uploads/2017/06/Gloria-Lemay.pdf. Accessed 29 Nov. 2020.

Hasebe-Ludt, Erika, Cynthia Chambers, and Carl Leggo. *Life Writing and Literary Métissage as an Ethos for our Times.* Peter Lang, 2009.

Ogilvie, Clare. "Popular Midwife Appeals Five-Month Prison Sentence for Contempt." *Pique: News Magazine,* 1 Aug. 2002, www.pique newsmagazine.com/whistler-news/popular-midwife-appeals-five-month-jail-sentence-for-contempt-2462475. Accessed 29 Nov. 2020.

Tritten, Jan, and Gloria Lemay. "Midwives Under Fire." *Wise Woman Way of Birth, Gloria Lemay Birth Blog,* 24 Oct. 2012, wisewoman wayofbirth.com/midwives-under-fire/. Accessed 29 Nov. 2020.

Chapter Thirteen

Death and the Mother: Integrating Death into a Pagan Family Life

Cory Ellen Gatrall

As a labour and delivery nurse, I regularly witness one of life's great transformations. What began roughly nine months prior as two cells meeting in a dark alley, emerges, sticky and screaming, as a newborn infant. As the umbilical cord is clamped and the first breath drawn, interior pulmonary and blood pressures shift, inflating the lungs and closing holes in the heart. Dawn breaks inside each baby, as its newly oxygenated body blushes from purple to red. It takes some babies longer than others. Learning how to live in this world is hard.

Learning how to die is easier. We all manage it, eventually, regardless of what we're told or not told beforehand. But learning to understand death—what it is and what it means—this is one of the core tasks of cultural, religious, and spiritual traditions as well as an important developmental milestone. Helping my children to understand death in a manner consistent with our family's Pagan beliefs has been one of my great challenges and great joys as a mother.

In any single day, death may present itself to us on our dinner plates, announce itself from the newspaper on the table, or stare at us from the side of the road as we drive to school. In many families, such small encounters pass silently or perfunctorily, whereas open discussion is reserved for big deaths—of public figures, pets, friends, or family members. My husband and I could easily have made this choice, fortunate

as we were; what losses we had in our children's earliest years were mostly distant and not entirely unexpected. But from the time our kids could talk, death has been an intentional part of our household conversation, spoken of often and without drama. Over the years, it has become apparent to me that such deliberate integration of death into daily life is uncommon among my fellow parents of young children in other faith traditions, many of which view death as a stark endpoint, or a profound transition to an afterlife, rather than a vital part of an ongoing cycle.

This should not really have come as a surprise. Death was explained to me by my own academic, atheist parents as, simply, the cessation of life. What happens after? Nothing. But "nothing" was not a concept I could wrap my mind around. I was seven when my friend's father died suddenly of a heart attack; when she came back to school a few days later, she explained that he had been "put in a freezer." In retrospect, I assume she was referring to the morgue, but at the time, I connected this to the technology of cryonics. For years, I imagined his body in a state of suspended animation, waiting for scientific progress to reach the point where he could be brought back to life. Not long after that, I lost the cat who had been my companion since infancy, and then I lost a grandparent; my grief in both cases was exacerbated by my incomprehension. Terrified of the nothingness of death, I refused to allow it. All my dead were gathered into a collection of ghosts, wafting silently into the room whenever I thought of them. I built a kingdom of imagination in which death was a long-distance phone call or a veil, which could be twitched aside at a whim.

At nine, still fearful but beginning to glimpse alternatives, I set out to explore different religious paths—I sang in an Episcopalian choir, sat silently in Quaker meeting with my best friend's family, and was dropped off at Sunday morning Hebrew school. None of these paths spoke to me; the Christian services felt uncomfortably like a betrayal of my Jewish heritage, and the synagogue was filled with children raised in their religion, who treated me like the outsider I was. I stumbled across Starhawk's *The Spiral Dance* at the age of eleven in a used bookstore, and there found my spiritual home, identifying first as Wiccan and later as more broadly Pagan. The divinity of nature and self, the interdependence of all things, the magic of the world around me and the unendingness of life; all of these were truths I recognized and felt deeply.

Pagan spirituality gave me the framework I needed to reconceptualize death. I came to understand death as a change of state, a transformative process wherein that which has been a cohesive "me" for a few years dissolves back into the ancient and universal "us." Unlike many religious traditions, this perspective is one fully at ease with modern science: Carl Sagan told us in his 1980-television show *Cosmos* that "We are made of star stuff," and in that program's 2014 reboot, Neil DeGrasse Tyson reiterated, "We are biologically connected to every other living thing in the world. We are chemically connected to all molecules on Earth. And we are atomically connected to all atoms in the universe. We are not figuratively but literally stardust." The scientific principle of conservation is consistent with Pagan beliefs about death: as matter, mass and energy can neither be created nor destroyed, rather only transformed from one state to another, in the same way the atoms and molecules that make up our being only transform. I have found this idea of continuity to be a concrete as well as a deeply reassuring foundation for helping my children to explore ideas of life and death.

Growing comfortable with death requires intimacy with dying and with decomposition. Adults may draw back from such encounters, but it is in the inquisitive nature of children to engage deeply with them. When our twins were very small, I invited them to recognize the small, everyday deaths around them: shining beetle shells at the base of a tree, worms on the sidewalk after a rainstorm, and upside-down spiders with their legs curled into a fist. By the time they were three, they often held elaborate funerals for the ubiquitous earwigs found near our home, each of which was solemnly named "Pinchy." They learned to put their leftovers into the compost bin, which they would later poke through to see its progress towards soil. We put that soil into the garden and grew food from it. These small, simple actions were enough to establish their understanding of death as a crucial part of life.

That understanding was tested last year. We brought two kittens home in mid-July, one for each of the twins. My son, Renzo, claimed the gray tortoiseshell who hid under couches and perched on bookshelves; his twin named the smaller, friendlier, black one Orbit "because she runs around and around." Orbit's batlike ears twitched as she hung ungracefully over Ari's bony shoulder, purring despite the desperate love unleashed upon her.

Both kittens came to us infected with intestinal worms, which we

treated per the vet's instructions. Not a big deal, happens all the time. But while the gray kitten recovered, Orbit began to fail. Her fur dulled; she ate less and less. We got more medicine and fluids to administer subcutaneously. After three weeks, the vet sighed and offered euthanasia. We asked her if Orbit was in pain, and hearing she was not, we brought our kitten home to die.

That night, before they went to bed, the children said goodbye. I lay on the couch, Orbit wrapped in a towel on my chest. Both kids cried. Ari kissed the kitten's fragile whiskered face with its half-closed yellow eyes. Orbit died, still purring, before dawn.

All the preparation we had provided, all of the daily work to recognize death, did not prevent the children from grieving—nor was that ever the goal of this practice. Grief is important work, which allows us to process and integrate experiences of loss into our psyches and our stories. Their grief, however, did not overwhelm them or send them into spirals of fear as mine had years before. They mourned her physical absence, and they cried over not being able to cuddle or play with her anymore, but their understanding that her death was part of something rather than the end of something gave them resilience. There was sadness, but there was no despair.

While the kitten brought my children into a closer relationship with death, it was the approach to motherhood itself that put me on intimate terms with my own mortality. Struggling to gain weight throughout my pregnancy, nauseated and fainting by turns, and, by thirty weeks gestation, nearly unable to walk, I was acutely aware that my children's bodies were being literally mined and moulded from my own. As a high risk obstetric patient, I was also frequently reminded of the dramatic climax looming ahead, which could plausibly result in the beginning of two new lives or the end of three. At night, trying to find the least uncomfortable position in my nest of seven pillows, I would listen to my heart pumping double its usual blood volume through a circulatory system nearly at capacity, ticking down the hours. The birth, a Caesarean section, split me in half while I was still awake, like the old magic trick at which the audience shivers in horror, wondering how the magician's assistant can possibly survive. This entanglement of life and death brought me new appreciation for the interdependence and continuity of all things, which I already understood to be true.

Becoming a mother was not a moment but a process. It did not occur

at my children's birth; it began before, and continues still, with their ninth birthday only a few weeks away. Extricating a coherent identity as a mother from the morass of cultural messages and biological realities is a dynamic practice that requires daily attention. My own motherhood is not dependent on having grown my children in my body and nursed them with my breasts, but neither are those facts irrelevant to my experience.[1] Most of my mother identity, however, rests in my acts of mothering.

In most ways, ours is not a traditional role-abiding household: my male partner does the laundry, dishes, and much of the childcare, while I pay the bills and work outside the home. Yet some traditional mother jobs have remained mine. I put in the work of maintaining extended family connections; I care for the illnesses and injuries; and I guide our children's spiritual and moral development as well as most conversations around values. This latter role has been of particular importance to me, perhaps because I forged my own path in this realm rather than having it laid out for me.

The work of integrating death into our lives feels especially appropriate for me in my role as mother. For most of history (and to this day, particularly in many places and for many groups of women), motherhood has been a perilous occupation. Any child raised on fairy tales—or the Disney-diluted versions thereof—learns to expect that a dead mother will figure in the narrative. For our family, this narrative is more than a story; my husband's first wife died many years ago at the age of twenty-eight. They had already lost a child several years before, and now he was left to raise their remaining nine-year-old son alone. The bereft father moved in with his own mother and sister, and those women, both of whom also died before my husband and I met, took over a number of the roles that I fulfill in our new family's life.

We have never hidden this story from our children, and as my children approach the age of nine, their interest in it has increased. Questions about "Simon's mama" have become more frequent. How did she die? How long did it take? Was Simon very sad? Was my husband very sad? How long were they both sad for? These are hard questions for my husband; with my support, he answers honestly and gently.

These concerns have inevitably led to the question "What if our mama died?" We have talked about this possibility, acknowledging openly that no amount of time together is guaranteed. As with children's questions

on many topics, it is important not to answer more than they are asking at any given moment; our conversations about the possibility of my death have mostly been focused on where I would be and how they would miss me. I would be in the earth around them as well as in the water and the air, I tell them. I would be in the peach tree in our back yard. They could rest their hands on the earth or sit in the stream and speak to me, and perhaps there would be no answer they could hear with their ears, but what which was their mother would be there nonetheless. This answer satisfies, or it at least has done so to date.

When Orbit died, we chose her grave carefully. Because her body would be returning to the earth, to decompose and merge into the soil, it was important to Ari that the kitten be buried in their garden. Over the fall and winter, fur and skin and flesh would separate, spreading and enriching the ground. In the spring, the spiraling roots of the garden plants would find nutrients there, and when the shoots broke through and reached for the sun, they would carry with them some of what had been Orbit. Each leaf, bud, and flower would hold part of our well-loved friend.

Endnote

1. To essentialize motherhood as biologically defined erases the motherhood of trans women and other gender nonconforming individuals who claim the mother identity. My identity as a mother is not contingent upon denying that identity to anyone else.

Works Cited

Druyan, Annd and Steven Soter. "Sisters of the Sun." *Cosmos: A Spacetime Odyssey,* directed by Brannon Braga, produced by Cosmos Studios, Fuzzy Door Productions, Santa Fe Productions, 2014.

Sagan, Carl. "The Lives of the Stars." *Cosmos: A Personal Voyage*, created by Carl Sagan, Ann Druyan, and Steven Soter, directed by Adrian Malone. Produced by Cosmos Studios, 1980.

Starhawk. *The Spiral Dance.* Harper One, 1999.

Notes on Contributors

Chandra Alexandre, PhD, is a Tantric Bhairavi who has served as a spiritual leader for the past twenty years in the San Francisco Bay Area through SHARANYA (*www.sharanya.org*), a federally recognized goddess temple she founded after receiving direction from her teacher in India to "Go and spread mother worship!" Dedicated to Her mysteries as pathways to personal transformation and social justice, Chandra works both in community and in the nonprofit sector for change. She received diksha (initiation) into Tantra in India, her PhD in Asian and comparative studies from CIIS (with an MA in women's spirituality), and her DMin in creation spirituality. She also holds an MBA in sustainable management and is a certified fundraising professional specializing in internationally focused causes and grassroots women-led change.

Arabella von Arx is a writer with a particular interest in the arts and women's issues. She is the New York and Paris art critic for West coast magazine *Riot Material*. Her articles, as well as scripts and short stories, have appeared in major newspapers and publications, such as *Le Temps* in Switzerland and *Litro* in the UK.

Elizabeth Cunningham is best known as the author of *The Maeve Chronicles*, a series of novels featuring a Celtic Magdalen. Her early novels, *The Wild Mother* and *The Return of the Goddess* have been released in twenty-fifth anniversary editions. In addition to numerous novels, she's published four collections of poems.

Alys Einion is an Associate Professor of Midwifery, creator of Centred Birth Hypnobirthing, lifelong feminist, writer, mother, and midwife, living in Wales, UK. Her research interests include midwifery

education, feminism and reproduction, motherhood, lesbian and queer families, women's life writing and narratives, and narrative construction. She is a novelist, an avid and unashamed bibliophile, and an advocate for LGBT + rights within the workplace.

Cory Ellen Gatrall is a registered nurse, working in labour and delivery as well as abortion services. She also holds an academic appointment as a Five College Associate with the Five College Consortium in Western Massachusetts, which supports her work researching and writing about the history of nursing and medicine.

Nané Jordan, PhD, is a birth-keeper, artist-scholar, community worker, and mother of two young adult daughters. Nané is devoted to women's spirituality, the divine feminine/female, Mother Earth, and Goddessing worldwide. She has been an advocate, practitioner, and researcher of mother-centred birth for over thirty years, and completed an MA in women's spirituality (New College of California), a PhD in education (University of British Columbia), and was a SSHRC Postdoctoral Fellow in women's and gender studies at the University of Paris 8, France (*redthreadprojects.blogspot.ca*). Nané currently works in Indigenous family services, and was a lecturer in art education at University of British Columbia. She pursues narrative, arts-based, life writing research, and collaborative artistic practices (*www.gestare artcollective.com*); she publishes widely, including editing the anthology *Placenta Wit: Mother Stories, Rituals, and Research* (Demeter Press, 2017).

Christine Hoff Kraemer received a PhD in religious and theological studies from Boston University. She is the parent of a high-energy preschooler, an instructor in theology at Cherry Hill Seminary, a licensed massage therapist, and a practitioner of religious witchcraft. Her books include *Seeking the Mystery: An Introduction to Pagan Theologies, Eros and Touch from a Pagan Perspective: Divided for Love's Sake,* and the anthology *Pagan Consent Culture,* edited with Yvonne Aburrow.

Jennifer Lawrence has followed many gods for decades now. After college, she went on to work as an editor for Jupiter Gardens Press, a small publishing company in the Midwest. Her work has appeared in *Aphelion, Jabberwocky, Cabinet Des Fees,* and *Goblin Fruit.* She lives with two cats in Buffalo.

Asia Morgenthaler holds an MA in women's spirituality and a creative expression certificate from Sofia University (former Institute of Transpersonal Psychology). She is an artist, an intentional creativity facilitator, and a yoga teacher. Her paintings explore the relationship between art and spirituality, the feminine and nature, as well as creativity and intention.

Kusumita Mukherjee Debnath is an assistant professor in the Department of English of Rajganj College, affiliated to the University of North Bengal. She obtained her PhD in 2017 from Rabindra Bharati University in Kolkata for the thesis titled "Negotiating Postmodernity: The Novelistics of Walker, Morrison, Naylor, and Shange." Over seventeen of her scholarly articles have been published in national and inter-national books and journals of repute. She is also passionate about writing short fiction. Her stories have been published in *The Times of India* and in the e-journal *Muse India*.

Georgia van Raalte is a PhD candidate at the University of Surrey; her research explores the work of the British ceremonial magician Dion Fortune. She is also a magical practitioner, ritual creatrix, and creative writer, whose work explores manifestations of the divine feminine.

Molly Remer, MSW, MDiv, DMin, writes about thealogy, nature, practical priestessing, and the goddess. Molly and her husband Mark cocreate story goddesses, original goddess sculptures, ceremony kits, and mini goddesses at *brigidsgrove.etsy.com*. Molly is the author of *Womanrunes, Earthprayer, She Lives Her Poems, The Red Tent Resource Kit, The Goddess Devotional, Whole and Holy, and Sunlight on Cedar*.

Sarah Rosehill is a long-time member of the EarthSpirit Community, where she serves as a teacher, ritualist, event planner, member of the board of directors, and editor of the *EarthSpirit Voices* blog. She is trained in both Anamanta and Anderson Feri, is mama to a preschooler, and has a baby on the way!

Laura M. Zegel, LCSW, received her MSW from Columbia University and her MDiv from Yale University. In private psychotherapy practice for adults and adolescents since 1994, currently in Rockland, Maine, she has worked in a variety of settings, providing inpatient and outpatient psychotherapy. With a deep interest in women's and

adolescent girl's psychology, she has presented workshops and presentations on these subjects for the National Association of Social Workers Maine Chapter, the C.G. Jung Center, Brunswick, Maine, the Association for the Study of Women and Mythology's 2014 and 2017 conferences, and the Motherhood Initiative for Research and Community Involvement's 2015 Conference in Rome, Italy.

Deepest appreciation to
Demeter's monthly Donors

DEMETER

Daughters
Rebecca Bromwich
Summer Cunningham
Tatjana Takseva
Debbie Byrd
Fionna Green
Tanya Cassidy
Vicki Noble
Bridget Boland
Naomi McPherson
Myrel Chernick

Sisters
Kirsten Goa
Amber Kinser
Nicole Willey
Christine Peets